IMAGES
of America

EAST FISHKILL

IMAGES
of America

EAST FISHKILL

Malcolm J. Mills

ARCADIA

Copyright © 2006 Malcolm J. Mills
ISBN 0-7385-4460-4

Published by Arcadia Publishing
Charleston SC, Chicago IL, Portsmouth NH, San Francisco CA

Printed in Great Britain

Library of Congress Catalog Card Number: 2005936219

For all general information contact Arcadia Publishing at:
Telephone 843-853-2070
Fax 843-853-0044
E-mail sales@arcadiapublishing.com
For customer service and orders:
Toll-Free 1-888-313-2665

Visit us on the internet at http://www.arcadiapublishing.com

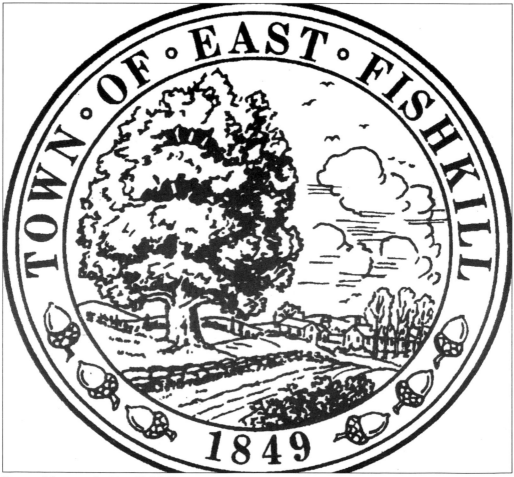

Pictured here is the East Fishkill town seal.

CONTENTS

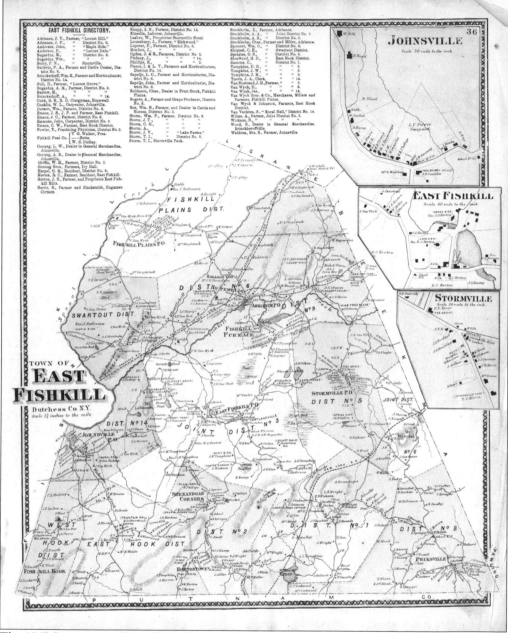

The 1867 Beers map of East Fiskhill is seen here.

INTRODUCTION

The Dutch settlements of New Amsterdam (Manhattan) and Fort Orange (Albany) were established early in the 17th century, but it took another several decades before anyone showed interest in settling on the eastern side of the Hudson Valley, which was low-lying and heavily forested. After England had reclaimed and renamed New York, King Charles II gave land on the east bank of the Hudson River to his brother James, Duke of York, in 1683. James named the county after his wife, the Dutchess of York. The archaic spelling of Duchess, with a *t*, has been retained.

Francis Rombout and his partner Gulian Verplanck realized the forests contained good lumber and beaver, whose skins were highly prized in Europe for hat making. They also believed the land could be drained, as had been done in Holland. So, in 1683, they purchased 85,000 acres from the Wappinger Indians. The sale was negotiated at Fishkill Landing on the Hudson, and the Wappinger received fair payment. The partners then requested official title, and on October 17, 1685, Gov. Thomas Dugan issued the Rombout Patent in the name of King James II, granting them land in "Dutchess County." The agreement allowed the Wappinger to continue to live on the land. However, in 1756, their sachem (leader) Daniel Nimham led his people to Stockbridge, Massachusetts, during the French and Indian War.

In 1683, Francis Rombout's third wife, Helena Teller, bore him a daughter, Catharyna, who became the future Madam Brett. When Rombout died, he left his "Land in Wappins" to his daughter. In 1707, the remaining three partners asked the Supreme Court to divide the land, and each received approximately 28,000 acres. This land included the modern towns of Beacon, Wappingers Falls, Fishkill, East Fishkill, and part of Beekman. Catharyna, now married to British naval officer Roger Brett, moved to her land in Dutchess County in 1709. The Bretts built the farmhouse that still stands in Beacon and a gristmill. Roger Brett was accidentally drowned in the Hudson a few years later, and of the three original partners, Madam Brett was the only one to then sell off parcels of her land, which were initially purchased by investors from Flushing and New Jersey.

The earliest settlement in what is today East Fishkill was near the Hopewell Reformed Church, on Beekman Road, which was then part of a throughway known as Madam Brett's Road. Settlers moved in and cleared the land for agriculture, and the community grew. Until 1849, the town had been part of Fishkill, and then in that year, the Town of East Fishkill received its own charter. The advent of the Newburgh, Dutchess and Connecticut Railroad, running north to Millerton in 1875, changed the character of the town. The commercial hub of Hopewell migrated to the area surrounding the railroad yards, and the new community of

houses and stores became known as Hopewell Junction when a second railroad line running east to west crossed the first tracks.

In 1900, the population of East Fishkill was a mere 1,970, and by 1960, this number had increased to 4,778. When IBM began operating a high-tech manufacturing facility between Route 52 and Interstate 84 in the early 1960s, a great number of jobs were created. Many of the new employees wanted to reside in the town, and the demand for housing resulted in new residential developments and the gradual loss of agricultural land. The influx of new residents continues today, and much of the rural charm of the past is being changed by commercial developments along roads that only 50 years ago were country lanes.

The area of the town is just over 53 square miles, and the population is rapidly approaching 26,000. Hopefully the new residents will come to appreciate and help preserve the few remaining historic houses that are scattered like gems in a sea of urban dwellings. There are still unspoiled parts of East Fishkill for everyone to enjoy that are still as they were almost a century ago, when most of the photographs in this book were taken.

One

HOPEWELL AND ADRIANCE

The town's first settlement, known as Hopewell, centered on the Dutch Reformed Church. The person responsible or reason for selecting the name Hopewell is not recorded. However, there are many other towns with this name, and it sounds pleasant. Henry Hudson, who first explored the Hudson River in 1609, had on a previous voyage crossed the Atlantic in a ship named the *Hopewell*—probably just a coincidence.

People built their homes along the dirt roadway that ran from Connecticut to Fishkill Landing, today's Beacon. The road was known as Madam Brett's Highway, as most of the parcels of land upon which folks had established homes and farms had been purchased or leased from Madam Brett. To attend Sunday religious service, these residents had to travel to Fishkill—not an easy journey in those days. So, in 1757, the small congregation founded the Dutch Reformed Church in Hopewell and began holding services in Isaac Lent's barn. In 1764, the first church, built entirely of wood, was ready for use. It is interesting to note that the church records were written in Dutch until 1781.

Mills were built to saw timber and grind grain, and the hamlet thrived until the advent of the railroads toward the end of the 19th century.

The road through Hopewell achieved new significance during the Revolutionary War, when it became a strategic route for moving troops, supplies, and other military matériel. It was renamed the Upper Road or Continental Highway. Generals Washington, Lafayette, Stuben, and others regularly passed along this road and stopped at the inns and homes. The road gained prominence when General Burgoyne's English, Hessian mercenary, and Canadian forces—defeated at the Battle of Saratoga—were marched as prisoners through Hopewell en route from Boston to Virginia in December 1778. As word spread of the marchers coming through the area, every able-bodied man, woman, and child turned out to line the road to see the defeated army trudge through Hopewell.

A post office was established in Hopewell in 1828. When the railroad came into town, however, a new post office was opened in Hopewell Junction, and in 1871, a new identity was given to the old Hopewell Post Office. The first postmaster of this new office was Abraham Adriance, who operated from his home, and so the area around the Dutch Reformed Church was known as Adriance. A historic marker at the junction of Beekman and Clove Branch Roads records the fact.

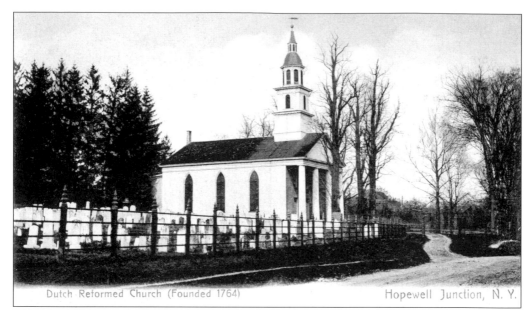

Dutch Reformed Church (Founded 1764) Hopewell Junction, N. Y.

The Dutch Reformed Church was founded in Hopewell in 1757. The indenture (contract of sale) hanging in the lobby of the church is the original 1761 document conveying the land upon which the church is built. Three years after acquiring the land, the first church was built entirely of wood. It is interesting to note that the church records were written in Dutch until 1781. The church was used for worshipping until 1833, when it was dismantled. It was replaced by the present church, which is constructed of brick and masonry.

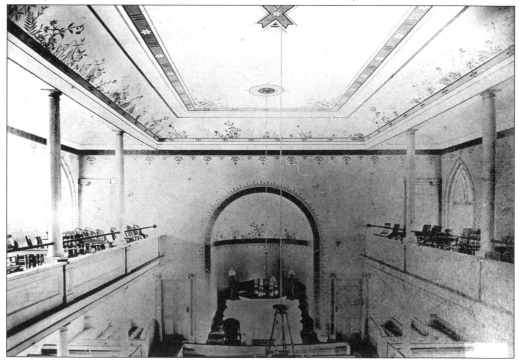

The interior of the Dutch Reformed Church is seen here as it was in 1900. A major restoration was completed in 2001, and the interior is now in pristine condition.

This photograph of the Hopewell Reformed Church parsonage, which stands in the parking lot of the church, was taken in 1875. The Rev. Graham Taylor, seen wearing a straw hat, is with his wife and daughter. He was pastor from 1873 until he retired in 1880.

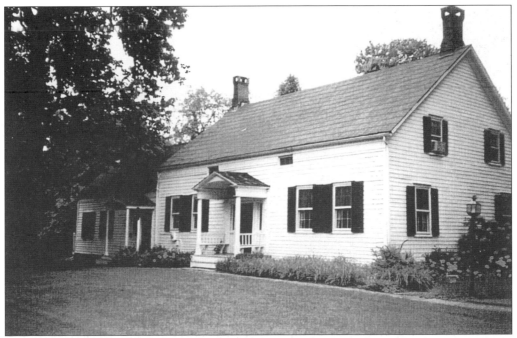

The Isaac Lent house, on Beekman Road, was built around 1754 or 1755 on land purchased by Isaac Lent from Madam Brett. From 1757 to 1764, when the first church at Hopewell was complete, the members of the Church Society of Hopewell (Dutch Reformed) met in Lent's barn, now gone.

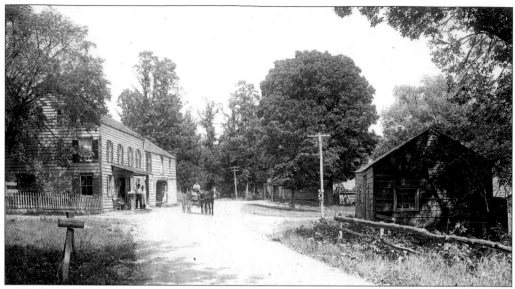

The junction of Carpenter, Beekman, and Clove Branch Roads is seen around 1900. The buildings on the left were torn down when the junction was widened.

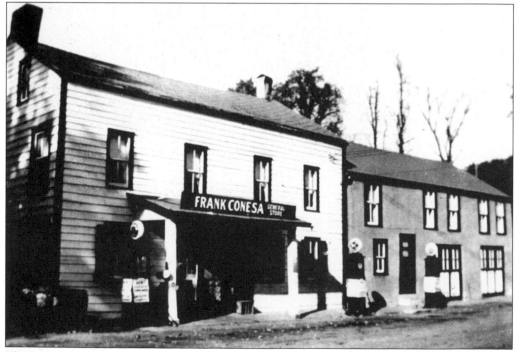

This is Frank Conesa's store as it was known during the early 1900s at the Clove Branch and Beekman Roads junction. The last owners, before the store was demolished, were the Kennasses. There was a blacksmith's shop nearby.

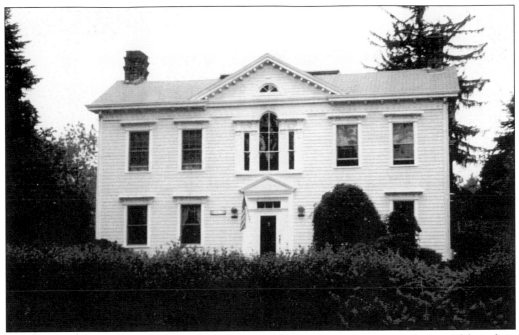

The Aaron Stockholm house was built around 1819 and is on its original site. Although it underwent many Colonial Revival–period transformations, it retains some of the town's finest Federal details.

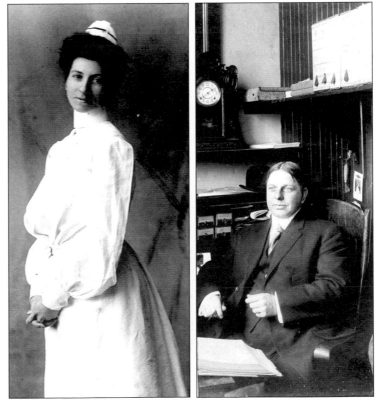

Here are portraits of two Stockholms: Grace J. in her nurse's uniform and "Uncle Bert" sitting at his desk at the Old Dominion Steam Shipping Company.

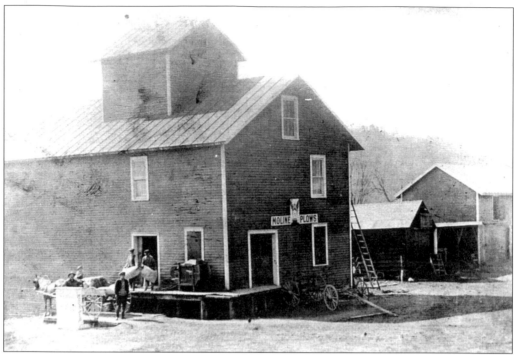

McKeown's Mill was on Beekman Road, almost opposite the Reformed church. There was a cider mill in the shed on the right of the large building. The mill was dismantled long ago.

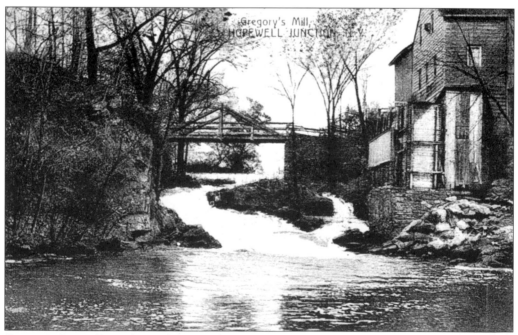

Gregory's Sawmill was located along the Fishkill Creek on Carpenter Road. Mr. DeWitt built the first mill in the mid- to late 1700s, and it may have been a gristmill. However, by the early 1900s, it was a wood sawmill and was owned by George Gregory.

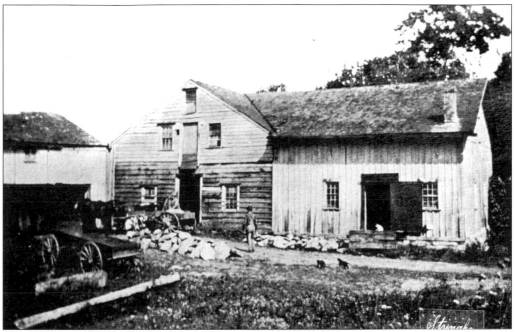

Shown are the barns and workshop at Gregory's Sawmill.

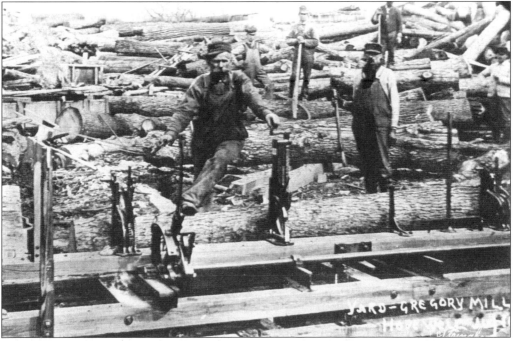

The wood-cutting operation is under way at Gregory's Sawmill. The young man with his hands on his hips is Kist Kelly, and the mill owner, George Gregory, is the man holding the handle of a log hook.

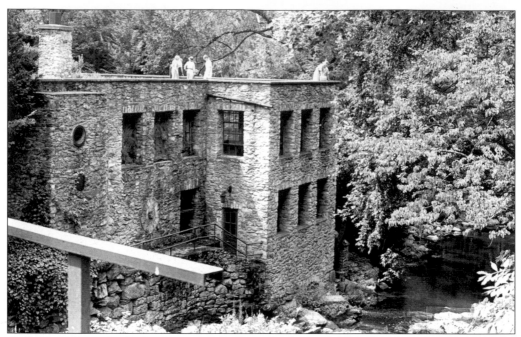

C. E. Carpenter rebuilt the Gregory Mill around 1930 and used it as a factory to build special electrical control devices that he had designed. He constructed a smaller waterwheel, which was coupled to an electrical generator and provided the energy to run his factory. The millpond remains although the generator is no longer used. Carpenter Road was named after this successful businessman.

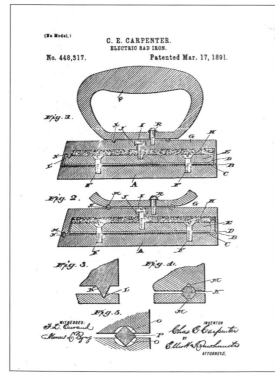

One of many patents issued to C. E. Carpenter was for an electric sadiron. He obtained the patent in 1891. This revolutionized ironing for housewives. No longer did they have to heat the heavy smoothing irons on a stove, a particularly uncomfortable task in summer, and swap handles onto a fresh hot iron.

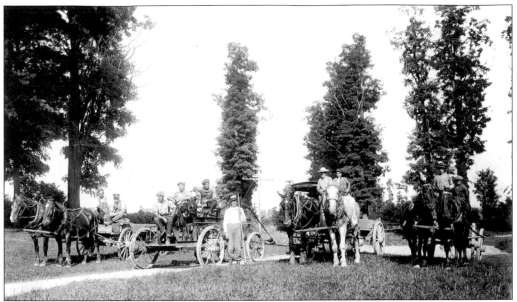

The Town of East Fishkill's road crew, in 1921, is seen in front of Brinckerhoff farm, the residence of Rev. Ernest Clapp, on Beekman and Phillips Roads. Reverend Clapp, from the Hopewell Reformed Church, is standing holding a pole. The man with the beard and straw hat is Jake Van Vlack, and Charlie McKeown's crew is on the right.

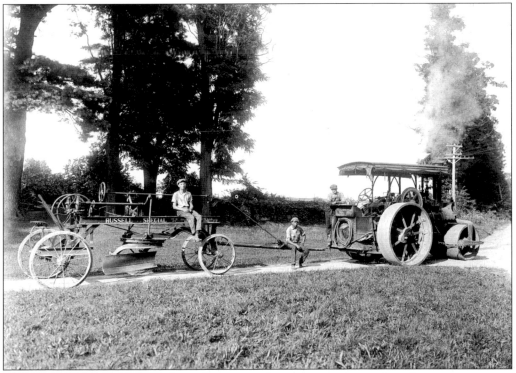

The Town of East Fishkill Highway Department's traction engine and road scrapper are seen here in 1921. Harold V. Mulford, sitting on the tow hitch, was the superintendent of roads, and Bill McKeown is on the steam roller.

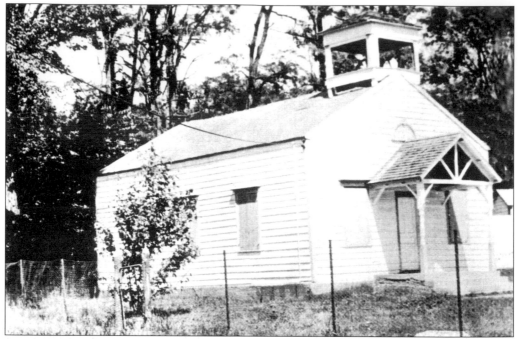

Old Hopewell School No. 9 was constructed around 1820 and stood at the corner of Beekman Road and the Taconic Parkway. Classes ceased in 1956. In 2003, it was moved to the East Fishkill Historical Society's site off Palen Road, Hopewell Junction.

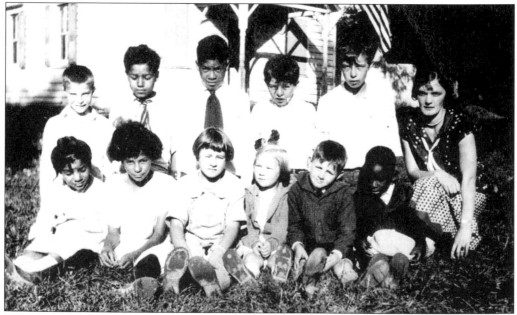

The teacher taught students grades one through eight in this one-room school. This photograph, taken around 1920 outside the front entrance, shows a typical group of children that attended school. From left to right, they are (first row) Rosa Thompson, Mildred Johnson, Natalie Vail, Adelaide Denk, Conklan Vail, and Jimmy Pitcher; (second row) unidentified, Joe Thompson, James Johnson Jr., two unknown students, and teacher Grace Phillips.

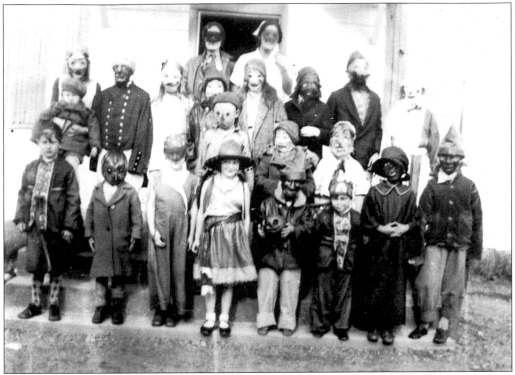

Students at Old Hopewell School are dressed in costumes for Halloween in 1924.

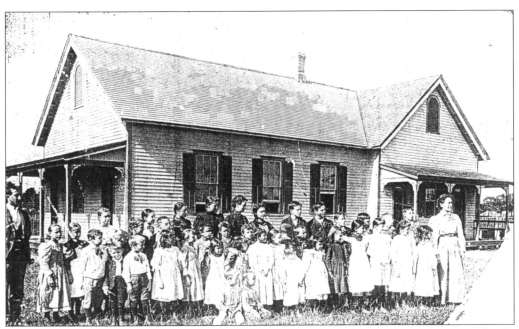

The three-room Hopewell Junction School had been used for teaching eight grades. It was finally closed in 1957. The school was located on Beekman Road, near the junction with Route 82, and burnt in 1986. This photograph shows students and their teachers outside the school in 1890.

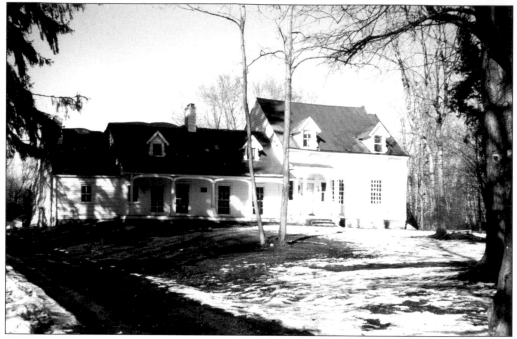

The Storm-Adriance-Brinckerhoff House (*c.* 1759), Plenty Acres Farm, on Beekman Road is the most historically significant house in town, as George Washington stayed here overnight on his 1776 march to Connecticut. On the following morning, the general came out onto the porch to find the whole neighborhood had come to greet him. The crowd stood bareheaded. "Put on your hats men," Washington called modestly, "I am but a man like you."

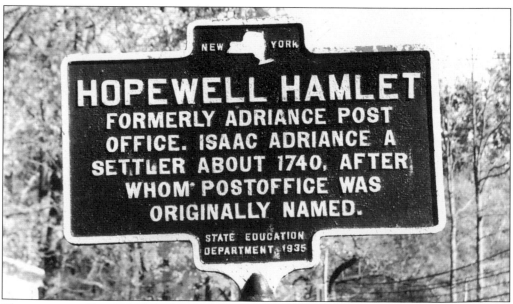

The new post office, established near the railroad depot in 1871, was named Hopewell, so the original Hopewell hamlet post office was renamed Adriance. Whether it was named after the early settler Isaac or the 1871 postmaster Abraham Adriance is open to dispute. Either way, it adopted the Adriance family name.

Two

GAYHEAD

The large agricultural farms in Gayhead have mainly disappeared, but fortunately, a few have been divided and are now horse farms. The narrow and winding roads in this district still retain their rural character, particularly those lined with fieldstone walls.

By 1868, the hamlet had grown enough to justify its own post office, store, and hotels. The hamlet's name is perpetuated by Gayhead Creek, which runs through the hamlet and into the millpond, which is now silted. In earlier times, before Route 52 was straightened, a tavern stood between the highway and the millpond.

Three stories relate to how the hamlet acquired its name. According to one, a lady living at the inn wore an elaborate hair arrangement and hence her name. A similar traditional story says that it was named for a man who habitually wore bright feathers in his cap.

The best story is of a young lawyer coming to the district to speak who was encouraged by his mother to put her curl papers into his hair to make an impression by having waves in his hair. Unfortunately, he forgot to remove the papers before giving his speech and, realizing too late, left them in. The locals assumed this was the latest fashion and hastened to adopt it. On the following Sunday, the account continues, those who attended the lecture appeared at Hopewell church with their hair tastily decorated in paper. They continued this custom before discovering their error. In the meantime, on account of their flashy headgear, the name of the village became known as Gayhead.

The hamlet of Gayhead encompasses a three-quarter-mile radius around the original town hall. Its first inhabitant was Aaron Van Vleckeren, who in 1720 purchased 600 acres from Madam Brett. He and his sons cleared the land and created profitable farms. James H. Smith, writing in the *History of Dutchess County* in 1882, observed that "few farming communities present a more prosperous appearance than around Gayhead, and none show more care and taste in the preservation of antique buildings, and other relics of the historic past, than the people of this town."

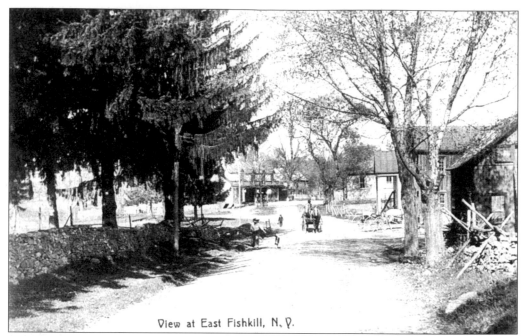

View at East Fishkill, N. Y.

The junction of Routes 52 and 376 is seen here as it appeared 100 years ago. In the center is the Gayhead Inn, tavern and store. These were demolished when the road was widened. To the center right can be seen the relatively new town hall and Taverner's wagon shop.

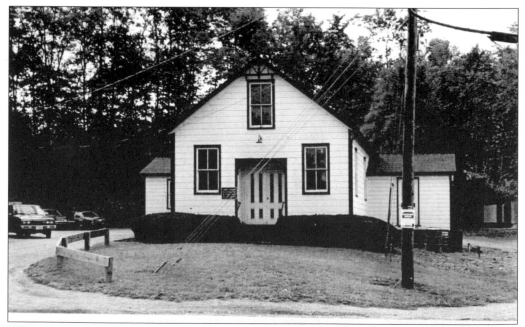

When East Fishkill was chartered in 1849, there was no town hall, and governmental services were initially conducted out of the officials' homes. In 1892, the first town hall was built at Gayhead on Route 52 at a cost of $367 for lumber and $1 for the donated land. It was in use until the new town hall was opened in 1965. The building is now the headquarters of East Fishkill Fire Department.

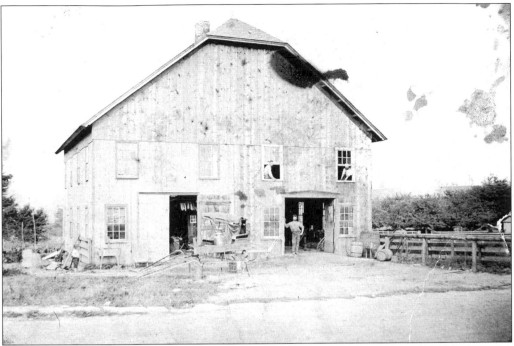

Al Taverner had a carriage and wagon repair shop in one side of his building and the blacksmith's shop on the other. This was how it was in 1905, before the motorcar had begun to replace horse-drawn vehicles. He lived in the house just visible on the right.

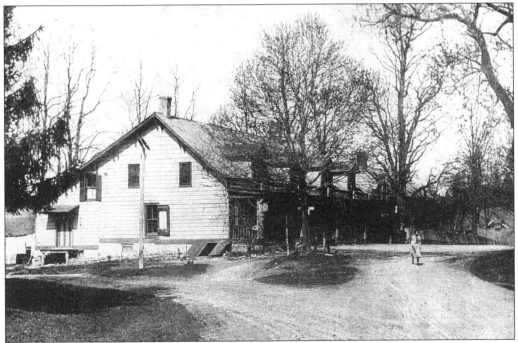

The Gayhead Inn, built before 1800, was located on Route 52 opposite the East Fishkill Police Station. The rear of the hotel backed onto the Horton's millpond. The hotel was demolished when Route 52 was widened.

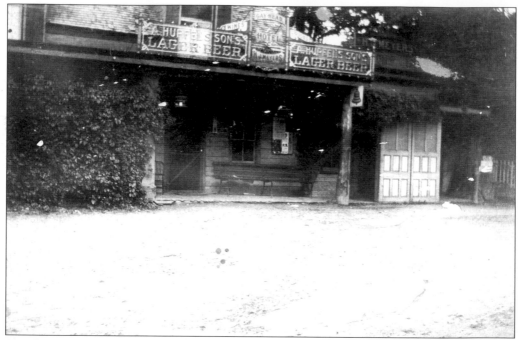

Seen here is the entrance to Gayhead Inn, tavern and store. H. J. Meyers was the proprietor of the hotel and general store. The Hupfel Beer Company had its brewery in New York City and a hard cider mill in Poughkeepsie. Otto Hupfel had a house in Wiccopee.

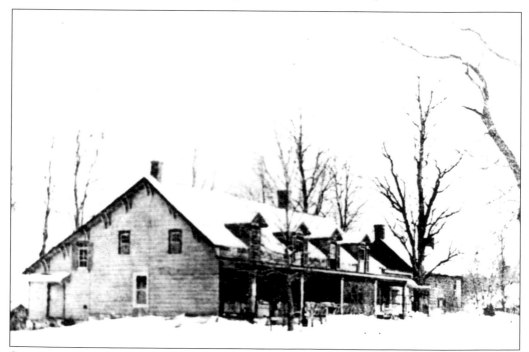

Snow-covered roads were not plowed during 18th- and 19th-century winters. Instead, large horse-drawn rollers were used to hard pack snow to make the surface suitable for sleighs. The Gayhead Inn looks rather bleak after a heavy snowstorm.

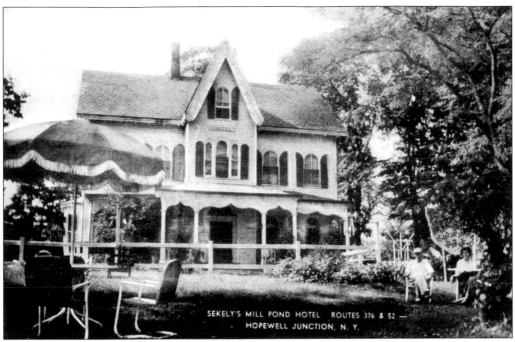

Sekely's Mill Pond Hotel was located approximately on the site of the Royal Motel, Route 376. According to some, the bar was a frequent gathering place for the young men of the town.

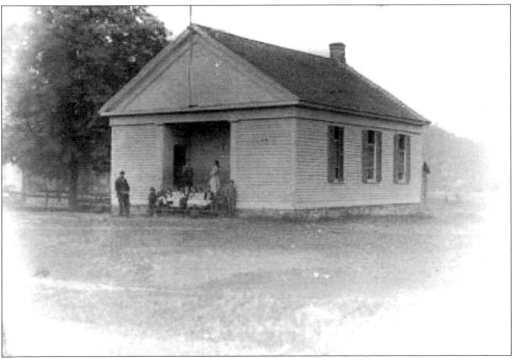

Grades one through eight were taught in Gayhead's one-room schoolhouse No. 3, which closed in 1935. The building is now incorporated into Rand Manning Real Estate's office on Route 52 west of the parkway.

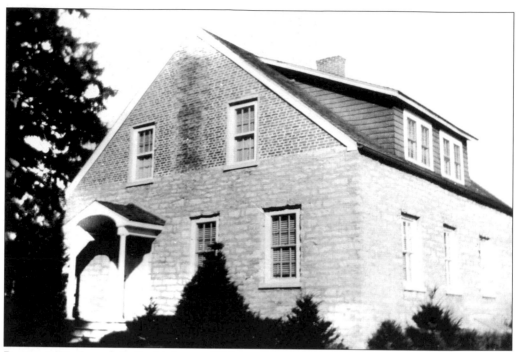

Benjamin Hasbrouck built this house 1755, according to an inscription carved in the wall. It is one of the oldest houses in the town, and apart from the dormer windows, added 50 years ago, the exterior is original. It is the town's only remaining stone house.

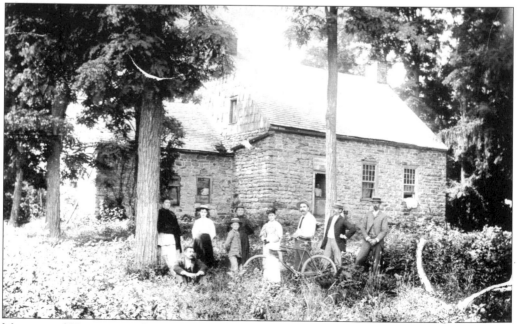

Morgan and Harriett Emigh lived in the Hasbrouck house in the late 1800s. They are seen in this 1893 photograph with their daughter, Mrs. Sil s Anderson's family, and friends in the backyard.

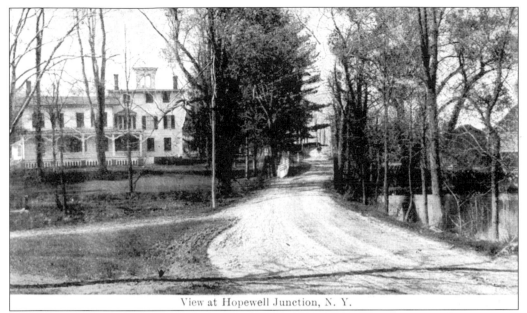

View at Hopewell Junction, N. Y.

This is the view along Route 376 toward the Inn at Stone Creek restaurant, when it was a private residence, around 1910. This Italianate building incorporates the original stone house built in 1741 by Tunis Van Vlack. During the late 19th century, Italian-style houses became fashionable in the Hudson Valley, and it was in 1882 that this building was enlarged and given its present exterior. The first gristmill on this site was built by Tunis Van Vlack in 1770.

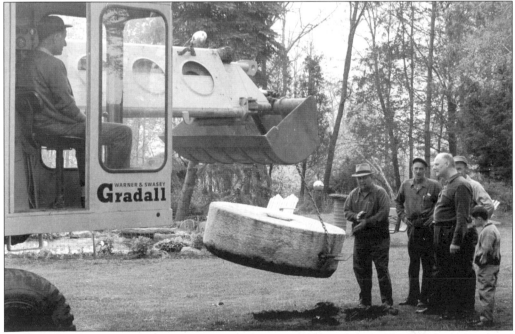

Fortunately, the Weitz family from Stormville rescued one of the millstones from Gayhead Mill and generously gave the stone to the town for display in the foyer of town hall. Kenneth McKeown and George Speeding of the highway department are seen moving the stone from the Weitz property.

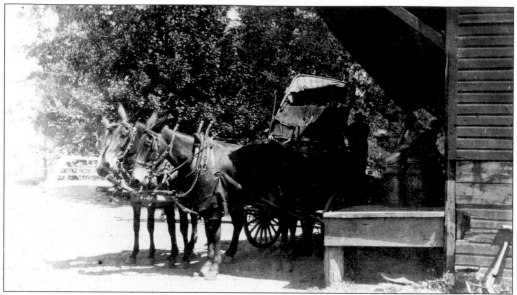

There was a milk collection station alongside Gayhead Creek, where the town's highway garage stands on Route 82. A three-mule team hauled the milk cans daily to Fishkill Landing and crossed by ferry to the processing creamery in Newburgh. This probably ceased when Borden's Creamery opened.

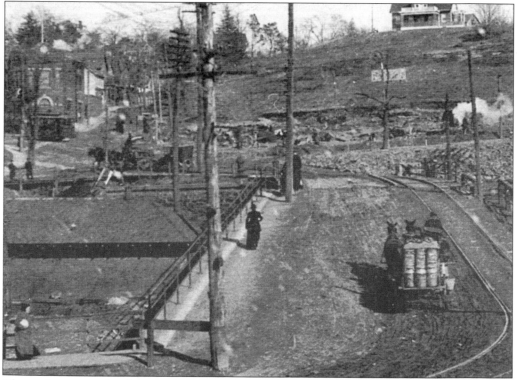

The mule team and milk wagon are spotted arriving at Fishkill Landing, after the 12-mile trek from Gayhead. The stacked cans were wrapped with wet sacks and covered by a tarpaulin during summer to keep the milk cool.

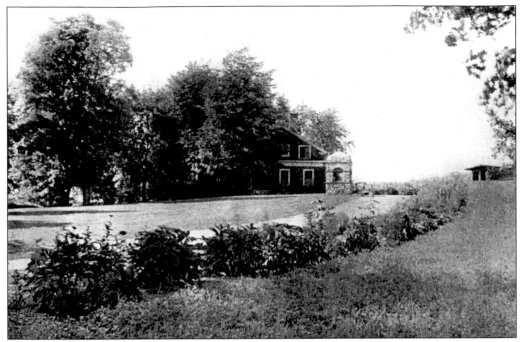

This is referred to as the J. C. Penney house, even though J. C. Penney, the founder of the department store chain that bears his name, never stayed there. It was the farm manager's house. Penney regularly visited his farm but stayed in a large private apartment in the boardinghouse where the single men lived. The farm was named Emmadine, after Penney's wife.

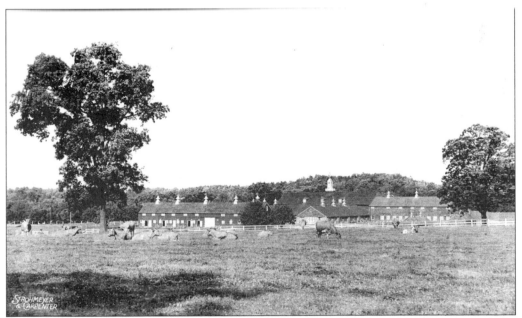

Emmadine Farm was a famous Guernsey cattle-breeding farm, with special maternity sheds for calving, the latest milking shed, and generally fine farm buildings. The property is no longer a farm. The buildings have been saved and converted into apartments, and Gayhead School has been built on the cow pastures.

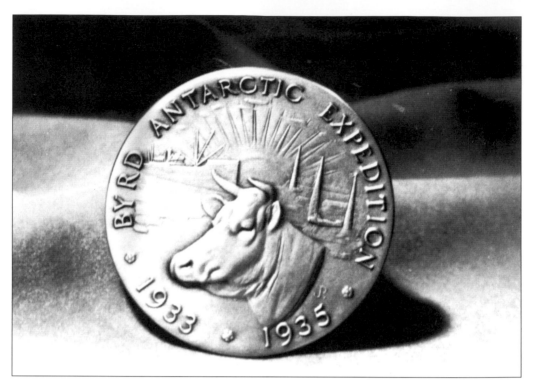

In 1933, Jimmy Dodge, Emmadine's manager, offered Adm. Richard E. Byrd a cow to provide milk for his South Pole expedition. The cow, Foremost Southern Girl, was shipped with hay and medicine to Antarctica. She returned healthy a year later with her calf, born in Antarctica, and was awarded the expedition medal.

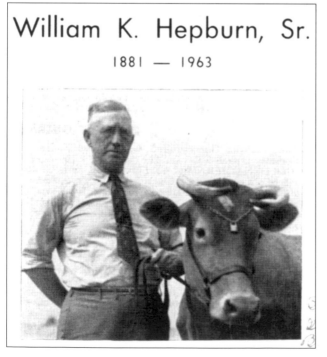

William K. Hepburn, Sr.

1881 — 1963

William K. Hepburn Sr. (1881–1963) was appointed manager of Emmadine Farm in 1934, following the sudden death of his good friend Jimmy Dodge. He spent 19 years as manager of this great breeding establishment and contributed much to development of the Guernsey breed.

Three

SHENANDOAH AND HORTONTOWN

Shenandoah, which remains as the town's last rural community, is located in the southeastern part of town. It was spelled as Shanodore on some early maps, but this has been dropped in favor of the current spelling. According to Henry Gannett's *The Origin of Certain Place Names in the United States*, Shenandoah is a Native American word said by some to mean "the sprucy stream" and by others, "a river flowing along side of high hills and mountains." This latter description seems appropriate for the relatively unspoiled pastoral views down the valley.

The inevitable pressure for converting agricultural land into new housing developments has not yet reached this corner of the town. Farming is still carried on as it has been since the first farmers cleared the land in the mid-1700s. Today the many farmhands, who once worked in the fields and milked cows, have been replaced by modern methods and highly mechanized labor-saving machinery. The Jackson family's farm has the only milking herd left in the town. The farm has been in their family for over 100 years, and one must wonder how much longer the "black and white" Holstein cows will be seen in the verdant pastures. There were once many such dairy farms in the town to supply milk to the large population of New York City.

Similarly, on the other side of the Taconic Parkway, Elton Bailey's herd of "red and white" Hereford beef cattle is one of only a few remaining beef producers left. To look at the Shenandoah Valley today is to see how much of East Fishkill would have appeared as recently as 70 years ago. There can be no going back, but it would be a shame not to retain this corner of the town as a reminder for future generations of those earlier times when agriculture was the dominant economy.

Hortontown is a small hamlet located at the southern end of the Shenandoah Valley. Its name is derived from the many Horton families that made their homes there. In 1860, David Horton operated a sawmill and gristmill on the stream flowing into Gayhead Creek. The hamlet once had its own store, and the little Methodist church is still standing, although it is not in regular use.

The Dutchess-Westchester Turnpike, an important road link to the south, ran through the Shenandoah Valley. Sections of this winding road, which is lined with fieldstone walls, can be followed, but one will see none of the horse riders, sheep drovers, and peddlers who once passed along.

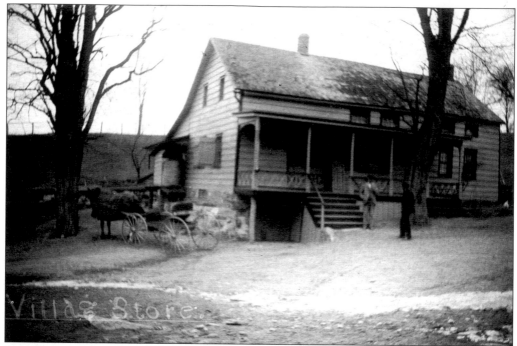

The Shenandoah Store is seen here around 1900. When the store first opened sometime in the early 1800s, the local people took their butter, eggs, and so forth to trade for tea, coffee, and merchandise. The last owner, Joan Contratti, ran the store until it closed in the 1990s. The neighborhood blacksmith's shop was opposite the store.

This photograph of Townsend Road, in the winter of 1905, shows Harry Mead's house in the distance. The road looks very much the same today.

The Bethel Baptist Church was built in 1834 at an estimated cost of $2,500 and was dedicated in December 1835. The two ladies in the driveway are Emma E. Knapp (left) and Jennie E. Lyons.

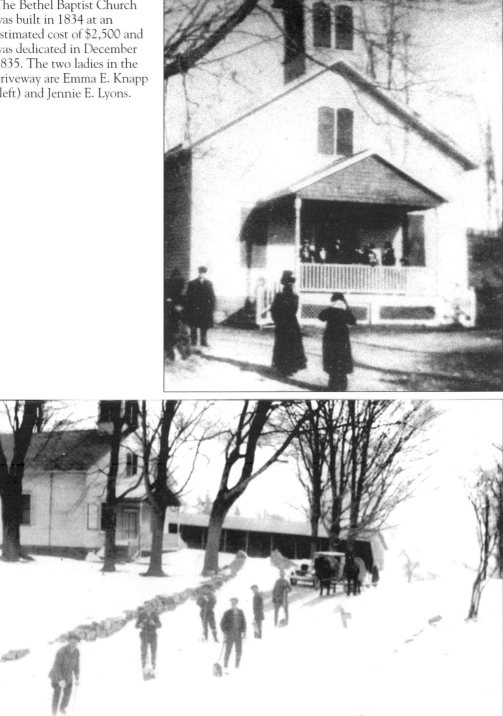

The town's highway crew is clearing snow on Shenandoah Road by Bethel Church around 1932. The long row of sheds behind the church is for parking horse-drawn carriages or sleighs to protect them during the services.

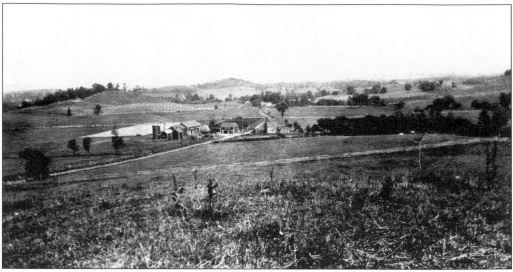

This view is of Jackson's Farm looking north before Route 84 was constructed. The year 1992 was the centennial of Jackson families' ownership of the farm. There were once many dairy farms in the town, but theirs is the only one still in operation, with a herd of 60 Holstein cows.

Here is a winter scene, looking across the apple orchard toward Hosner Mountain. This is before the Taconic Parkway carved a path across the base of the mountain.

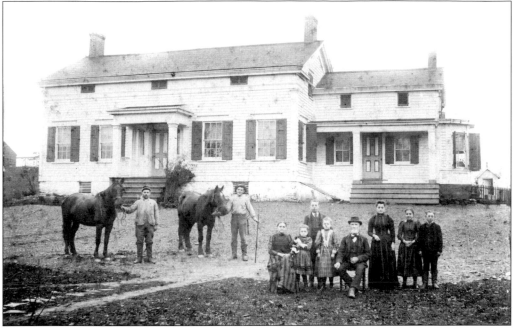

Thomas Wright, with the beard, was the father of Jennie Wright, grandfather of Wright Jackson and Edna Jackson, and great-grandfather of Vern and Wayne Jackson and Jane Morris, to name but a few of his descendants. Thomas and his wife, sitting on the left, had 14 children. This photograph in front of the farmhouse on Noxon Road is dated 1881.

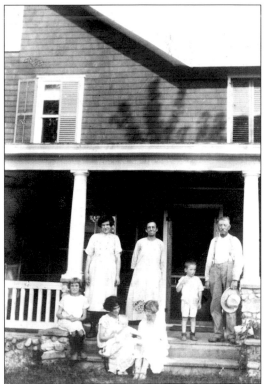

Jane Morris's grandparents, William and Jennie Wright, are on the porch of the Jackson farm in 1932. Jane is the baby cradled by a cousin on the steps. Her brother is standing next to his grandfather.

TO COVER,

The beautiful BAY HORSE,

MOLTON;

At Mr. Richard Jackson's, in the County of Dutchefs, within four

Miles North-eaſt of Fiſh-Kill Town, at Forty Dollars the Seaſon,

Twenty Dollars a Leap, or Eighty Dollars to enſure a Foal.

MOLTON is now rifing eight years old, fifteen hands and an half high, remarkably ſtrong, lengthy and handſome, was got by Wildair, his dam by Sampſon, ſhe was full ſiſter to the Marquifs of Rockingham's Bay Molton, Pilgrim, Solon and Tom Tinker, and of Mr. Finton's Engineer, Sire of Mambrino, the beſt-horfe in England, Archimedes and many other good runners; his Grandam was got by the Godolphin Colt, a well bred fon of Lord Godolphin's very famous Arabian; his great Grandam was got by Partner, ſhe was the Dam of Lapwing, and full ſiſter to the Dam Blamelefs, Prophet and Trunnion, her Dam by Old Greyhound, her Grandam by the Curvan Bay Barb, her great Grandam by Lord Darcey's Cheſnut Arabian, great great Grandam by White-Shirt, out of the old celebrated Montague mare.

This horfe is well calculated to get Racers, Hunters, Saddle and Carriage Horfes. His Colts prove very fine, and chiefly Bays.

It is ſo cuſtomary to over-rate the good qualities of the Horfes advertifed for covering; and fo common to afcribe perfection to them all (though few merit what is faid of them) that I ſhould forbear faying any more refpecting Molton : But as fome perfons are yet ignorant that he is full blooded ; I now inform them that he is full blooded, that he has been moſt carefully and regularly bred, and that he is, by good judges, deemed the beſt full blooded horfe in this State.

N. B. Any gentleman putting a Mare to this Horfe to enſure a foal, and then parting with the fame, without convincing the owner that ſhe does not prove with foal, ſhall be liable to pay for the foal ; by reafon after parted with from the firſt owner, they go through many different hands, by which means the owner has not a chance to know whether they prove with foal or not.

RICHARD JACKSON.

Fiſh-Kill, March 12, 1779.

FISH-KILL: Printed by SAMUEL LOUDON.

Richard Jackson's stallion Molton is offered for breeding. The poster was printed on Samuel Loudon's press, which he moved to Fishkill when the British occupied New York City during the Revolution. Note the use of the print type ƒ for an s in the middle of a word.

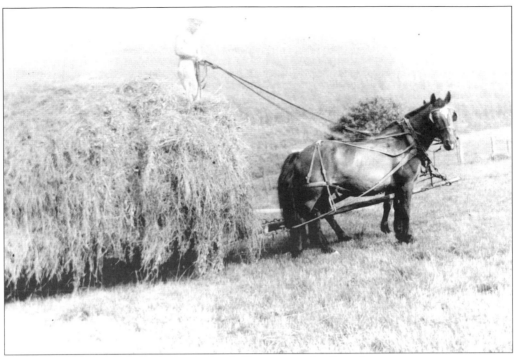

Wright Jackson is perched on top of a loaded hay wagon, holding the reins.

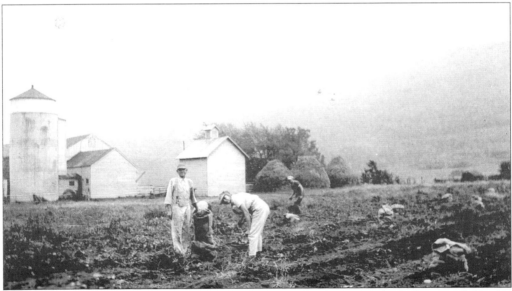

This is backbreaking work! From left to right are Wright Jackson, Edythe Jackson, and Charles Ketcham, potato harvesting in 1930. The icehouse in the background is still standing, although it no longer serves its original purpose.

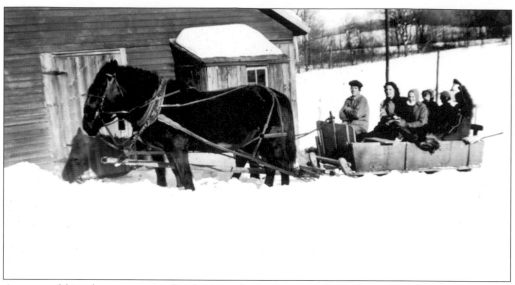

A group of friends enjoys a sleigh ride through the snow on the Jackson farm. This utility sleigh was also used to take the milk cans to the nearest creamery each morning.

The icehouse at Jackson's farm, Shenandoah, is seen here. Before refrigeration, blocks of ice were cut from ponds in winter and stored in insulated buildings. The ice was used to cool milk and foods in summer. Most farms in East Fishkill had an above-ground icehouse.

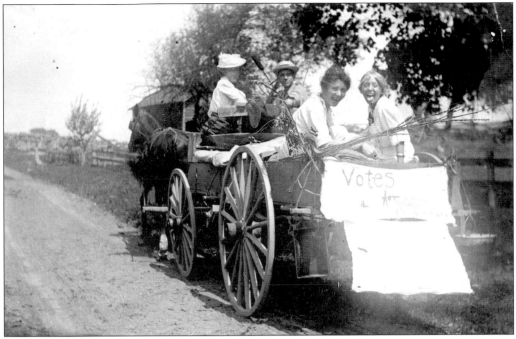

Edna Jackson (far right) and other suffragettes are seen on the "Votes for Women" campaign trail in 1920.

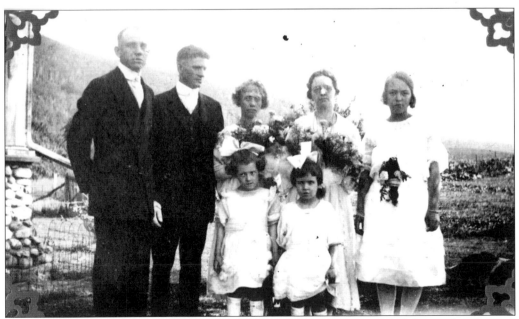

This is the wedding of Edna Jackson to William A. Wright in 1923. From left to right, they are Wright Jackson, town historian; William and Edna; bridesmaid Lecretia Knapp, who married Smith Townsend; and Lecretia's sister. Mina Adriance (left) and Lettie Borges are standing in the front.

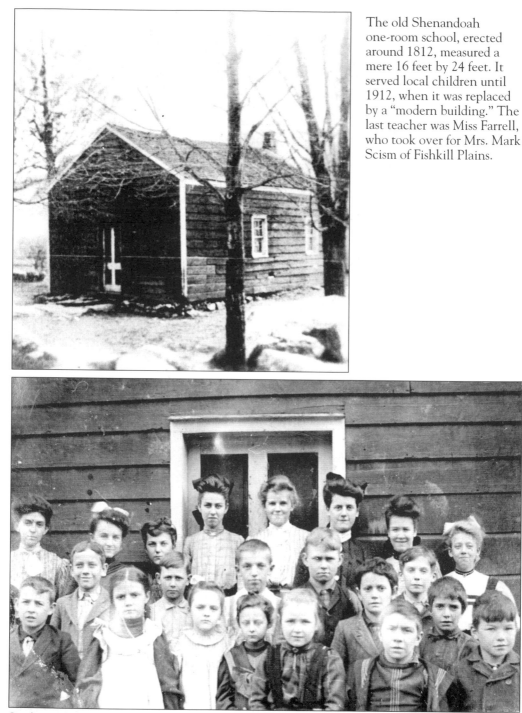

The old Shenandoah one-room school, erected around 1812, measured a mere 16 feet by 24 feet. It served local children until 1912, when it was replaced by a "modern building." The last teacher was Miss Farrell, who took over for Mrs. Mark Scism of Fishkill Plains.

Students at Shenandoah School in 1905 are, from left to right, (first row) Richard Kain, Hazel Purdy, Lucretia Knapp, Martha Harris, Hazel Lee, Ira Horton, Leslie Mekeel, Edward Horton, and Sherwood Robinson; (second row) Wright Jackson, Everett Lee, Roy Knapp, Ralph Lee, and unidentifed; (third row) teacher Runelia Wright, Lillian Kane, Alice Knapp, Viola Lee, Mamie Knapp, Bertha Stevens, Ethel Lee, and Edna Jackson.

Wright Jackson is sitting in the trap with a Horton sister, while the other heads the pony.

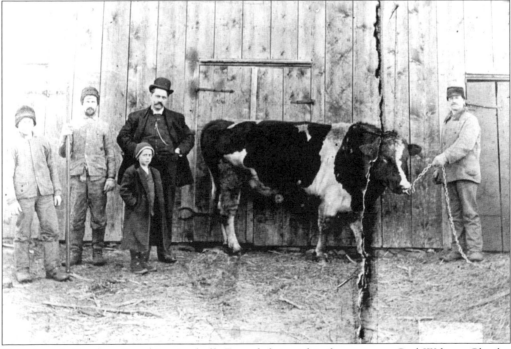

Seen here is Stephen Snook's prize bull. From left to right, the men are Carl Wilson, Charles Dingee, Stephen Snook, son Richard Snook, and Peter Losee, holding the bull.

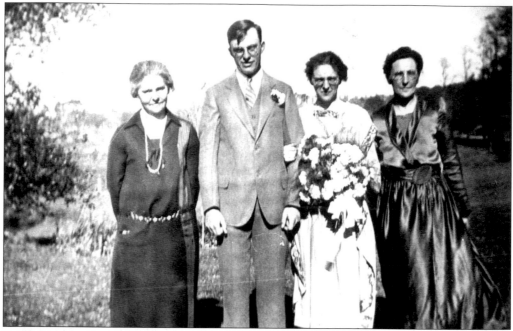

Smith Townsend and Lucretia Knapp, married on October 14, 1924, are pictured here with their mothers.

Holmer Knapp is seen here driving his Standard-bred horse to a buggy, with the hood partially raised.

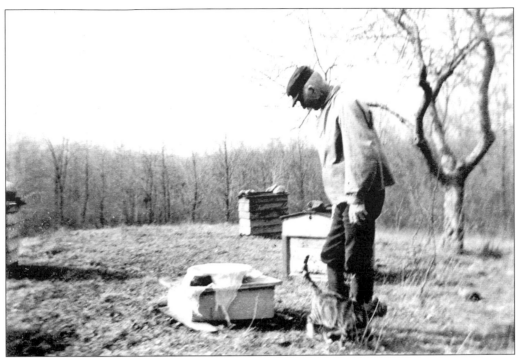

Ira Knapp is tending to his beehives in the 1920s.

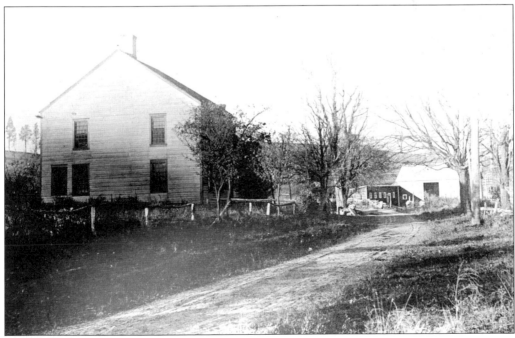

The Knapp house stands on Shenandoah Road.

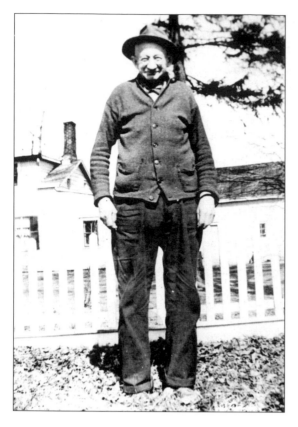

George A. Jaycox, married to Maude Horton, lived in the white Greek Revival farmhouse built in 1840, located at the corner of Jackson and Shenandoah Roads. The house remains but not the farmland, which once stretched on both sides of the road.

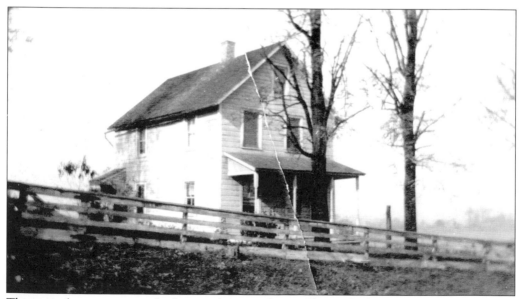

This typical tenant cottage for farm workers stands near Shenandoah Store and was occupied by Carl Wilson when he worked on the Jaycox farm in the late 1930s.

Elton Bailey's Silver Ledge Farm, on Hosner Mountain Road, is a working farm, with a herd of Hereford beef cattle. This fine Federal-period house was built in 1819, and P. Anderson owned the farm in 1867, when it was called Locust Dale. The house is significant for its intact Federal-period interior detailing.

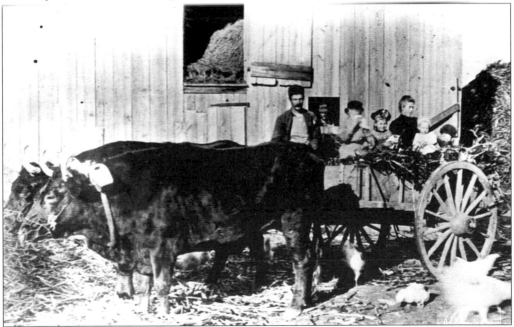

This yoke of oxen with a cart was typical on farms in the town around 1900. The people are, from left to right, hired hand Walter White; Bert Barrett, in the window; Louise (Barrett) Wood; Elsie (Barrett) Jerome; Mrs. Bert Barrett; and baby Drew Barrett.

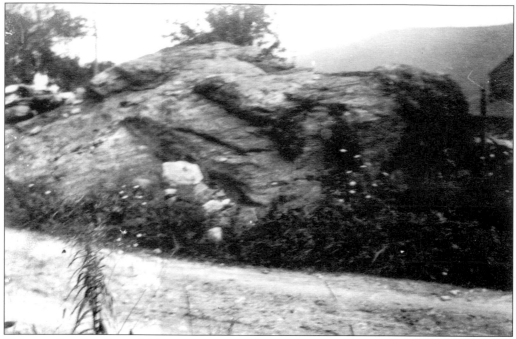

This massive boulder, which projects into the roadway at Shenandoah and Hortontown Roads, is known locally as Peddlers Rock. The roads were part of the Dutchess-Westchester Turnpike, and peddlers traveling along the "pike" would lay out their wares on this flat stone, and housewives would come to buy their pots, pans, and brushes.

Joe Horton and Lou Wood, wrapped in the flag, are seen celebrating Independence Day in front of the Hortontown schoolhouse.

Four

WICCOPEE AND JOHNSVILLE

The aboriginal people, who lived in this area before the first Europeans settlers came, have left no trace of their homes. They lived in agrarian settlements and also hunted and fished for food. Artifacts from their habitation have been discovered in the Wiccopee and Shenandoah areas, and it is known that they established apple orchards, the remnants of which may still exist today.

The Wiccopee were a subtribe of the Wappinger Indians and had villages at Fishkill Hook and on the flat land near Fishkill. They lived in exposed communities, and although generally peaceful, war between neighbors would break out. Encroachment on hunting reserves, theft, and occasional woman stealing were cause for fighting. They protected their villages with a stockade of wood posts set in the ground surrounding the wigwams and were known as castles or forts. One such fort stood on the high ground at Fishkill Hook, still known as Fort Hill. However, Henry D. B. Bailey, in his book *Local Tales and Historical Sketches*, written in 1874, mentions that he walked up the mountain to where the fort had been, but could find no remnants of the structure.

A few settlers married native women, and one such union is recorded on a headstone in a family cemetery on East Hook Mountain. The Wiccopee continued to inhabit this area long after they sold their land to the new settlers, until they finally moved away to western Massachusetts in 1756.

Johannas Swartwout was the first settler in Wiccopee and leased his farm from Madam Brett for a rent of three fat fowls a year. After Madam Brett's death in 1764, her grandson Rombout Brett inherited the farm and moved to it six years later. He sold six acres off by deed in October 1783 to William Cushman, who established the first blacksmith's shop. Sometime later, the community around the Methodist church prospered and was given a post office, designated as Johnsville. Thus, the hamlet adopted the new name, and to this day, maps identify the area as Johnsville. One of the first schoolhouses in East Fishkill was built in Johnsville in 1794 on a knoll near the Wiccopee Store. The younger children attended school during the day, and classes were conducted in the evenings for working youths seeking an education.

The houses and store along Fishkill Hook Road, in the Johnsville hamlet, are little changed from when they were recorded in the Beers map of 1867. To walk along this curved road starting at the Isaac Hawk wagon shop around to the Methodist church is like a step back in time. History is worth preserving, and this section may one day become the Town of East Fishkill's first historic district.

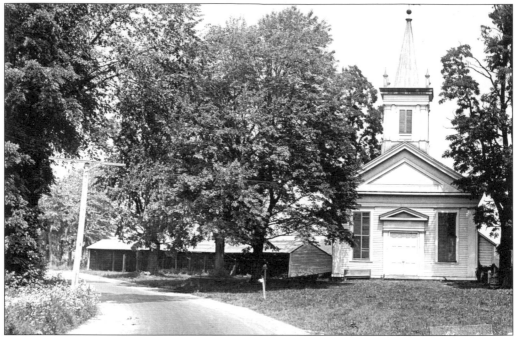

This strikingly beautiful Methodist-Episcopalian church is standing on its original site in 1914. The earliest section was built in 1826, and the bell tower, spire, and Greek Revival portico were added in the late 19th century. The church and the cluster of houses surrounding Johnsville Post Office stood on Old State Road until 1952, when Route 52 was straightened and cut the hamlet in two.

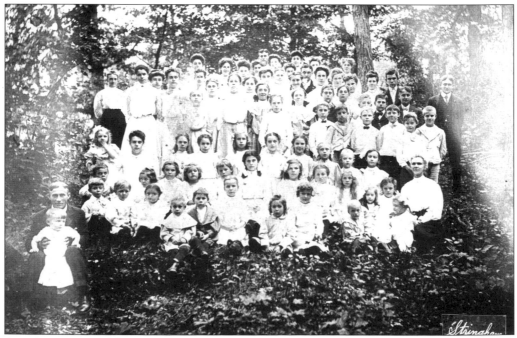

Seen here is the 1904 Johnsville Methodist Church Sunday school picnic held in the Meeting Woods Camp in the Wiccopee hills.

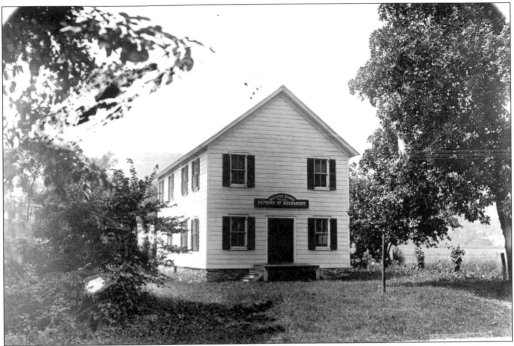

The Patrons of Husbandry Wiccopee Grange Hall is seen here. This hall is where farming families would gather for meetings and hold Saturday night dances.

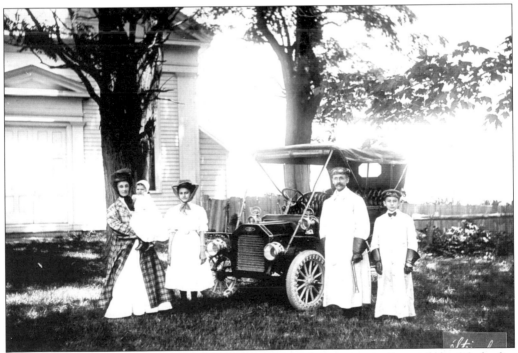

The Conros family is showing off its recently acquired motorcar in front of the Methodist church. They are all wearing the correct dress for the early motorists. Mr. Conros is holding the cranking handle in his left hand; there were no electric starter motors in those days.

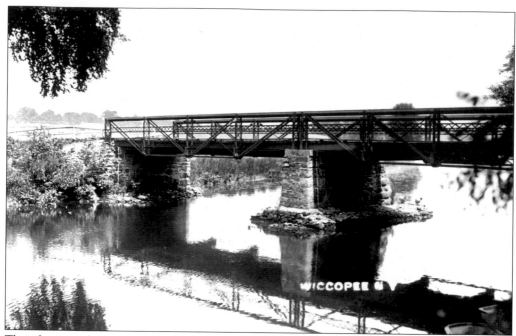

This photograph shows the bridge carrying Old State Road across the Fishkill Creek in 1910. There is evidence of an earlier wooden covered bridge, which would have kept snow from the carriage way in winter. The present concrete bridge was constructed in 2000, when the road was widened, and is located some 100 feet from the previous iron frame bridge.

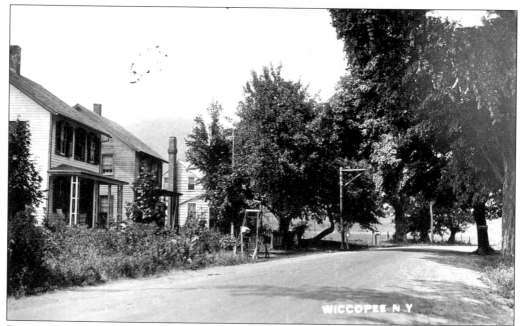

Route 52, also known as Old State Road, is seen as it wandered through Johnsville hamlet at the beginning of the 20th century. The section of Wiccopee named Johnsville, after the post office, is little changed from when the houses were first built around 1800. There is a possibility this will be designated as East Fishkill's first historic district.

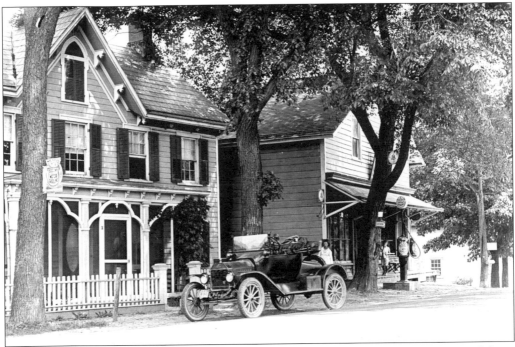

The Wiccopee General Store is seen here with its early gas pump, promoting Socony Motor Gasoline. The signs outside advertise a public telephone in the store. The general store has changed little in the last 80 years, except that the gas pump has disappeared.

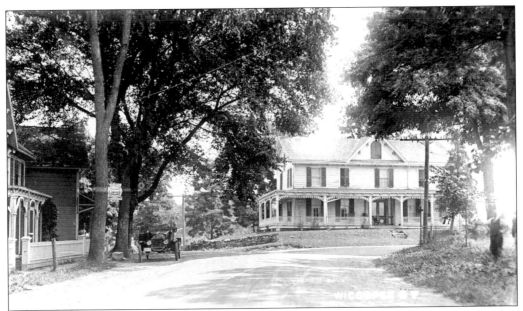

Henry D. B. Bailey, an author, lived in this fine house, opposite the Wiccopee Store. His father purchased the house in 1807. Bailey was born there in 1813 and sold it in 1866. There may still be timbers in the house that were salvaged from the Continental army's barracks in Fishkill. Much of the knowledge of the early settlers of the area comes from Bailey's book *Local Tales and Historical Sketches*, published in 1874.

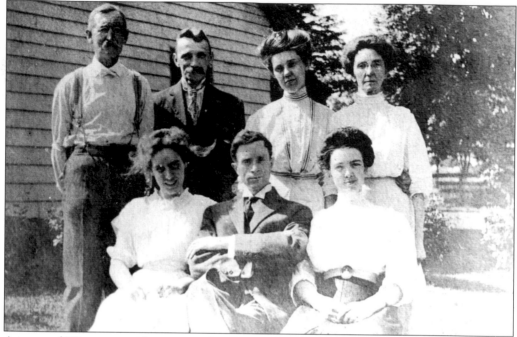

A group of Wiccopee residents is seen here in 1905. From left to right, they are (first row) Irene Vogel (stepdaughter of Joseph Chatterton), Marshal Doughty, and Blanche Doughty; (second row) Joseph Chatterton, West Bonney, Mrs. West Bonney, and Henrietta Chatterton.

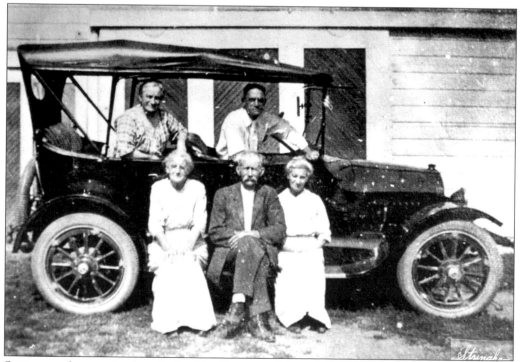

Sitting on the running board of a friend's car are Maria Strippel (sister of Henrietta), Joseph Chatterton, and wife Henrietta Chatterton.

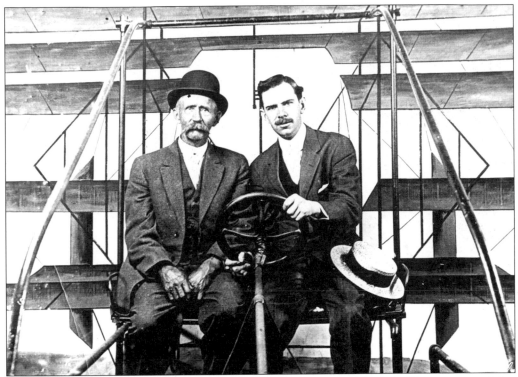

Here is a photograph taken at Coney Island in July 1913 of Joseph Chatterton and his stepson-in-law George Hallett, "learning to fly."

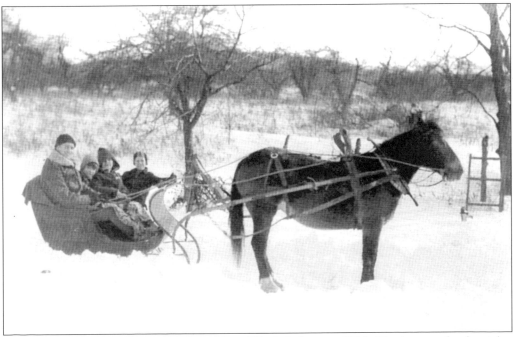

Sleigh riding is seen in a Portland cutter on Wright's farm in 1935. The boy on the far right, William A. Wright Jr., was killed flying in a B-29 bomber over Germany in World War II.

The East Hook one-room schoolhouse was on land next to Keepsake Farms. The building has been converted into a private residence, although externally it is unchanged from when it served the children of Wiccopee. Note the outhouse at the corner of the building.

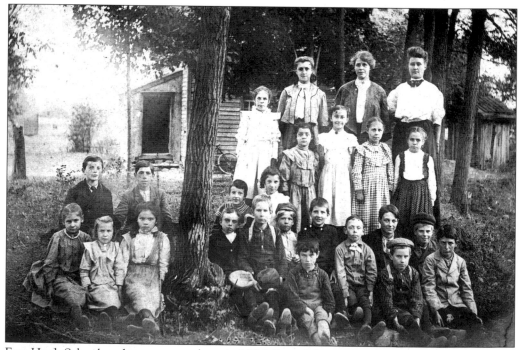

East Hook School students are seen here in 1906. From left to right, they are (first row) Lemuel Wixon, Louis Smith, and George Kilmer; (second row) Leila Heady, Lillian Heady, Jennie Wixon, Smith Townsend, Dan Smith, Ralph Hawkes, William Richards, Ralph Warren, Anthony Ellesworth, and William Wright; (third row) Henry Richards, Waldo Hawkes, Louise Richards, and Mary Richards; (fourth row) Della Wixon, Ruth Wright, Mary Ellesworth, and Hattie Hickman; (fifth row) Nettie Hickman, Ella Wright, Maude Hawkes, and teacher Carmie Hustis.

Martin Knapp's house on East Hook Cross Road is seen in 1898. Knapp is holding his dog, his daughter is cradling a cat, and "Aunt Birdie" is tickling a piglet. Esra Ketcham is amused watching "Auntie."

Seen here is a Knapp and Ketcham family photograph.

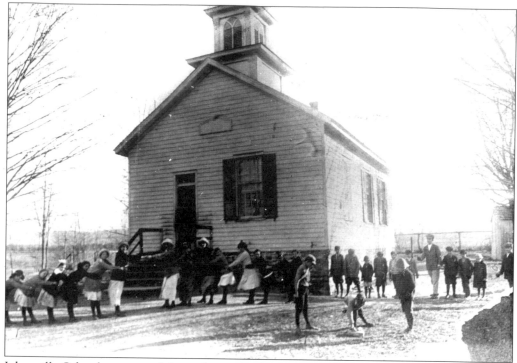

Johnsville School was one of the earliest schools in East Fishkill. It was situated on a knoll at the entrance to Fishkill Hook Road. It had a particularly elaborate bell tower, for a schoolhouse. The foundations, which are on Erickson property, are all that now remain. Albert Erickson is identified as the young man wearing a cap.

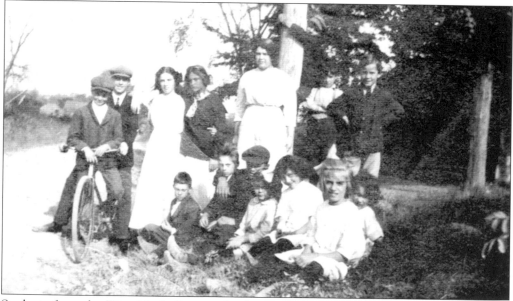

Students from the West Hook district school pose for a photograph. From left to right, they are (first row) Richard Booth, Del Wood, Lester Roth, Ruth Dotterer, June Dotterer, and two Goshvalere sisters, (second row) Smith Townend, Earl Ketcham, Emily Scofield, Pearl Hickman, Ann Dotterer, Theodore Heady, and George Dotterer. Climbing the pole is Roy Ketcham.

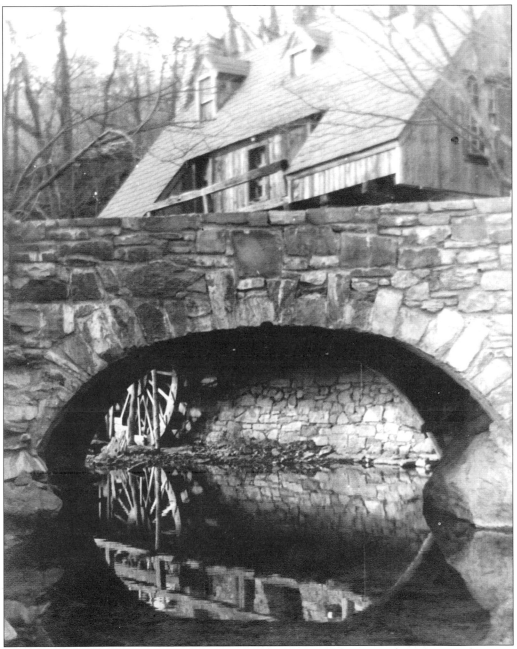

The mill wheel at the old Heady property on East Hook Road, near the Putnam line, is seen here. The history of the stone mill buildings is shrouded in mystery. Nevertheless, the wheel still rotates when the creek is flooded, and it is the only wood wheel still operable in the town. Bill Ormes had once owned this mill.

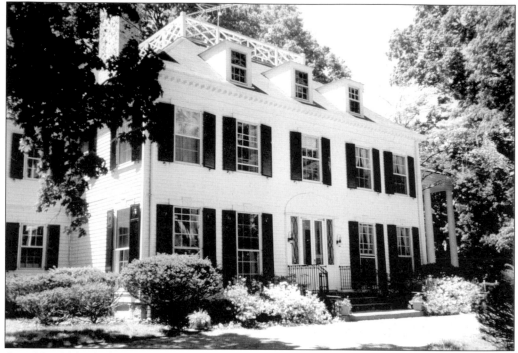

Otto Hupfel built this house, which was later the residence of Henry Morgenthau Jr., secretary of the treasury during World War II. Hupfel owned a brewery in New York City and used dray wagons to deliver beer to his customers. He built the large horse barn, which stands next to the house. From time to time, he would ship his dray horses from the city to the barn to recover from the toil of working in the city streets.

Seen here is Hupfel's tenant house. Ed Hickman's grandmother Rosetta Dotterer Doughty, when married to her second husband, Harry Doughty, worked at the Hupfel house and lived in the tenant house. The house, which no longer stands, was on East Hook Road, opposite the white painted schoolhouse.

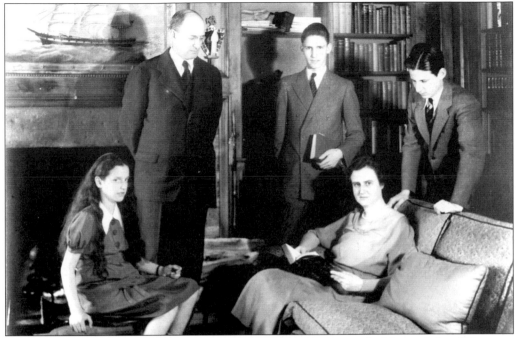

A 1938 holiday card of the Morgenthau family is seen here, taken in the library of their Wiccopee house. From left to right, they are daughter Joan, Henry Morgenthau Jr., son Henry III, Elinor Morgenthau, and son Robert, who later became district attorney of New York County.

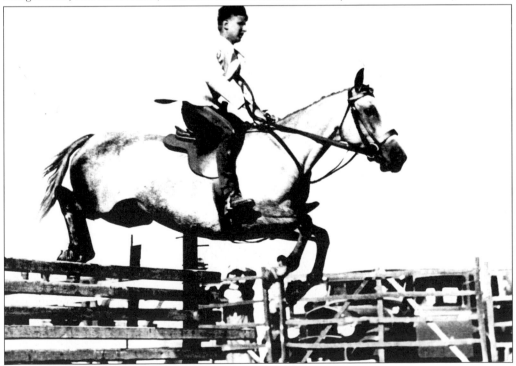

Robert Morgenthau is seen riding Blue Flint, competing in the Open Jumping Class at the Dutchess County Fair.

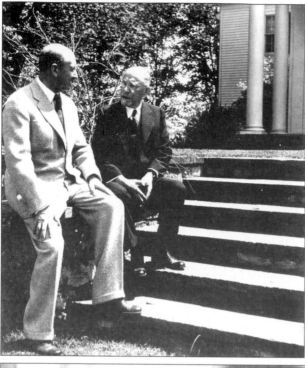

Robert Morgenthau's father, Henry Jr., and grandfather Henry Morgenthau Sr. are on the steps of the Homestead, their home in Wiccopee, East Fishkill.

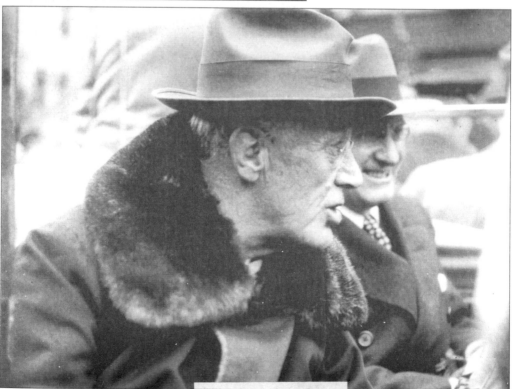

Pres. Franklin Delano Roosevelt and Henry Morgenthau Jr., secretary of the treasury, are seen in Newburgh on election day, November 6, 1944.

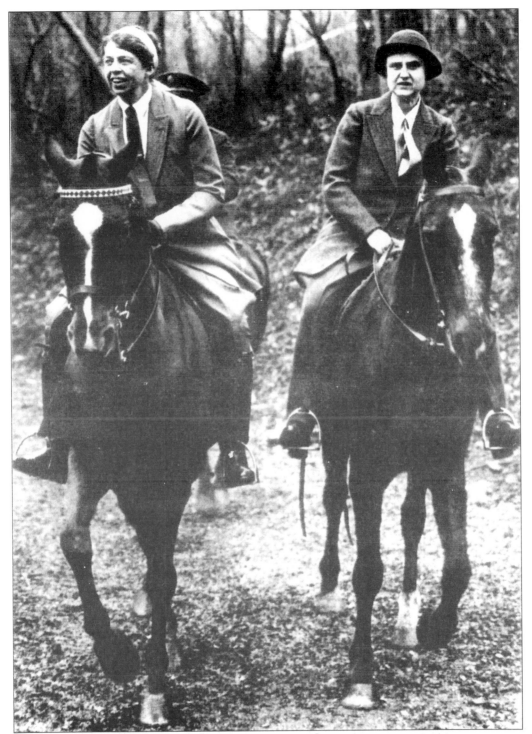

Seen here are first lady Eleanor Roosevelt (left) with Elinor Morgenthau, riding horses in 1937 at Rock Creek Park.

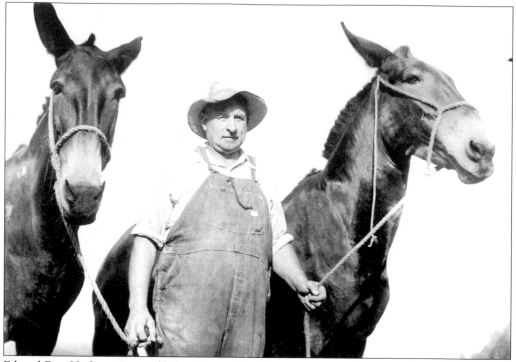

Ed and Ray Hickman's grandfather Harry Doughty, seen here with two mules, worked on the Hupfel and later the Morgenthau farm around 1920. Mules were popular for farmwork as they were considered smarter than horses and would avoid stepping into groundhog holes.

Michael Hickman's grave marker is seen in Copperhead Cut Cemetery. Michael, patriarch of the Hickman family, was a Hessian soldier serving with the British during the Revolutionary War. When the war ended, he settled in Wiccopee and married a Native American woman. The headstone reads "In Memory of Michael Hickman, a Native of Germany, who died Dec. 16, 1854 Aged 77 years. Also Freelove his wife, who died April 24, 1846 Aged 85 years."

The farmhouse of Eli Wright and Mary Hickman Wright is seen during the 1920s when they had boarders from the city staying in the summer. The farm was on land opposite Keepsake Farm Market, now part of East Meadow Road and Sebastian Court housing developments. The house burnt down in 1988.

In this photograph, kids are seen shooting rabbits for dinner, in Eli Wright's barley fields.

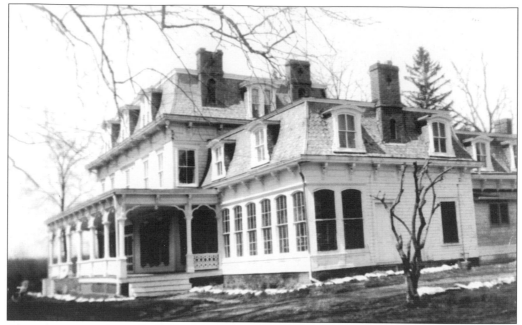

As a young man, Isaac B. Gildersleve worked on the Missouri River, eventually becoming a steamboat owner and trader. Then in 1865, he bought the Everett Hotel in St. Louis and, five years later, moved to the farm in East Fishkill (opposite John Jay High School). Here he built an Italianate-style mansion and ran a successful farm. A fire destroyed the house in 1968.

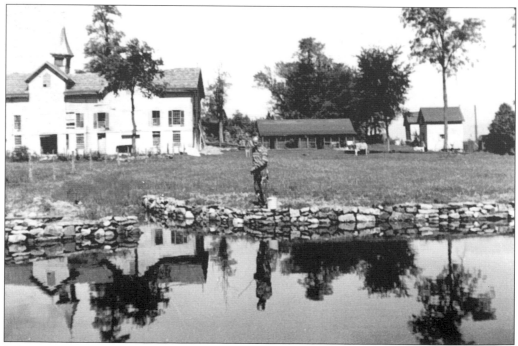

When Isaac B. Gildersleve died in 1890, his only surviving child, Rita, continued to manage the farm, making a specialty of milk production. These are the grand dairy barns, which were destroyed by fire.

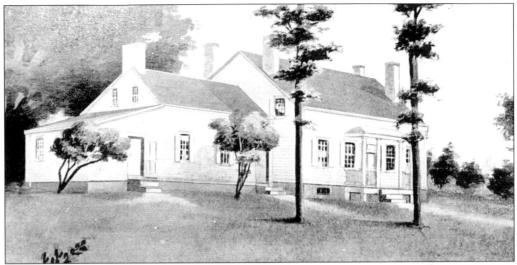

Theodorus Van Wyck settled in Wiccopee and built this house in 1740. After his death in 1776, the house passed to his son Theodorus, a physician who was a member of the Committee of Safety. Living with his wife's family, he rented this house to John Jay, who fled Westchester County with his family after the British advance. A band of outlaws raided the house and stole a large amount of silver. This print shows the house as it looked during John Jay's stay.

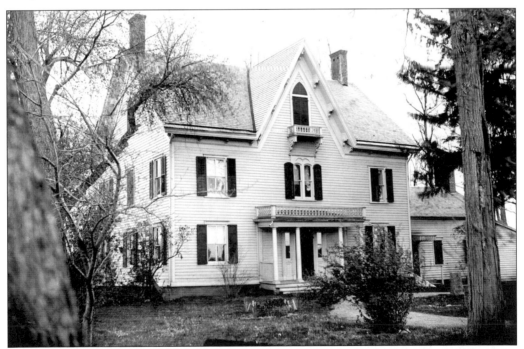

The John Jay house, as it was called, was enlarged and extensively altered in the middle of the 19th century. A second story with central gable was added, and the appearance of the house completely changed, as seen in this picture of the house in 1900. It was occupied until IBM purchased the property. The house was demolished in 1984 to make room for expansion of the IBM factory. The carriage barn was saved, and IBM paid to have it rebuilt on the East Fishkill Historical Society site.

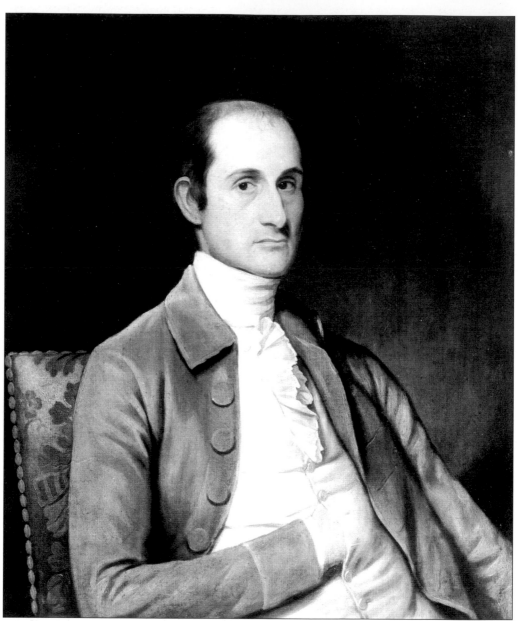

Seen here is a portrait of John Jay (1745–1829), who held the office of chief justice of the United States, and ended his lifelong public service as the elected governor of New York State. His inauguration took place on July 1, 1795.

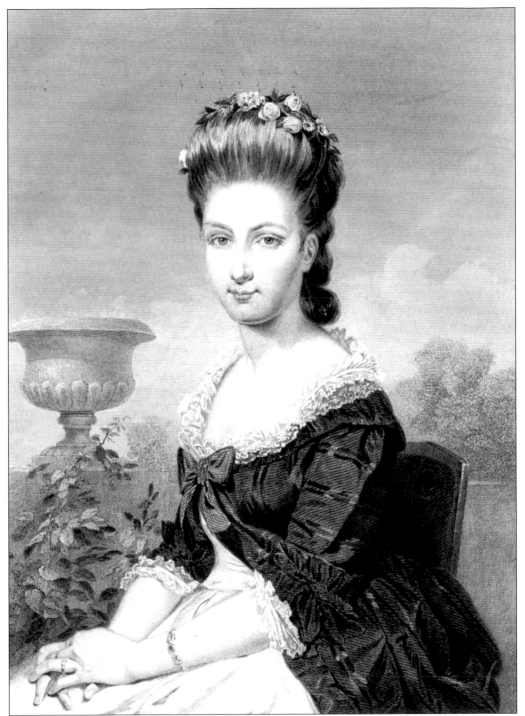

Seen here is a portrait of Sally Jay, wife of John Jay. Sally was a woman of endearing charm and vivacity, as well as great beauty, as her portrait justly portrays.

Gen. Abraham Van Wyck built this house in 1802 in part of the original tract of 900 acres purchased by his grandfather Judge Theodorus Van Wyck. The general acquitted himself with honor during the 1812 war. When IBM purchased the property, the company intended to refurbish the house as a conference center. However, circumstances changed in 1996, and the house was dismantled.

The inside page of the Van Wyck family Bible is seen here, inscribed with births and marriage records of Judge Theodorus Van Wyck's grandson's family.

Five

STORMVILLE
AND PECKSVILLE

From one look at a map of 1850, with its number of Storm family homes and farms, it is obvious where the community of Stormville acquired its name. It was usual to add the suffix "town" or the French "ville" to the majority residents' names to identify a hamlet. Surprisingly, Stormville had not always been the name adopted for this hamlet. The origin of the first name, Snarlington, is long forgotten. However, when the post office was established in 1826, there was debate about its name, and Stormville was chosen.

Most families from this area were involved in the Revolutionary War, not the least of which were the Storms. Garret Storm, who was 54 years of age and, so, too old for military service, was a known patriot. One night in 1777, a group of Revolutionary Tories raided his house. They hung Storm in his attic and left him to die. Fortunately, one of his slaves, Epye Schouten, was hiding nearby and crept unobserved and released him. Storm appeared none the worse for his ordeal and 20 years later made his will, in which he left a legacy to his faithful maid, Epye Schouten, and directed his executors to support Epye during her natural life.

The burial ground for the slaves who worked on the Storm farms still exists within a fieldstone walled enclosure on Phillips Road. The cemetery has recently been restored, and students from Vassar College made a survey of the site. Boulders and fieldstones are the only remaining grave markers; however, Nancy Rapalje mentions in a paper written in 1901 that "the names and dates could still be read on the old wooden headpieces, which were thought to befit the rank of slave." Unfortunately, the names of the people buried in the cemetery may never be known, except, perhaps, faithful Epye Schouten.

Pecksville, or Peck Slip as it was sometimes called, is the most southern hamlet in East Fishkill and Dutchess County, being on Route 52 beginning at the Putnam line. This route was known as the Turnpike, and there was a tollgate about a mile north of the hamlet, by schoolhouse No. 8. It was the route of the stagecoach and cattle drovers prior to the advent of the railroad. H. Smith's hotel and store was a center of activity as stagecoach horses were changed while the passengers took meals. There was another smaller hostelry known as Widow Peck's Hotel. Presumably it was Mrs. Peck whose name was adopted for the hamlet.

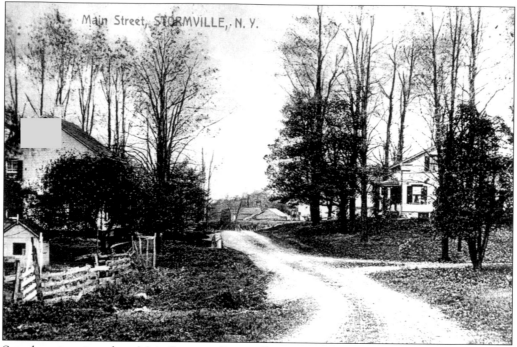

Main Street, STORMVILLE, N. Y.

Seen here is a view along Main Street in Stormville in 1900. The tracks of horse-drawn carriages are visible in the unpaved road.

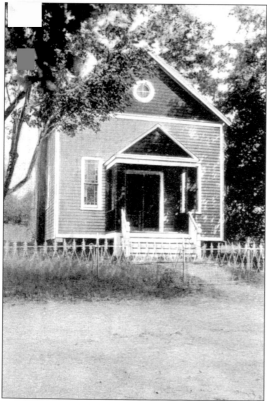

The Stormville Union Chapel was built at the end of the 19th century and has remained in use to this day.

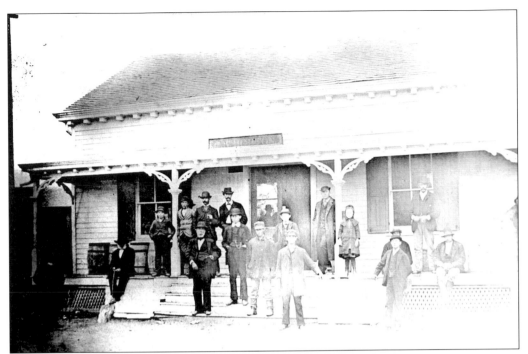

This view shows C. W. Horton's store and post office.

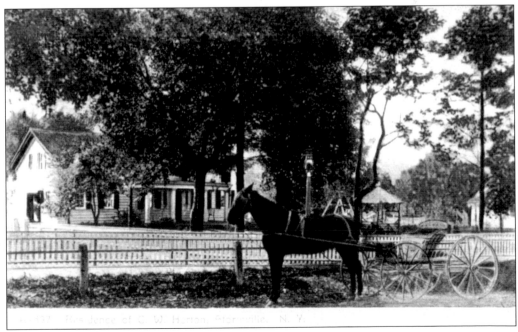

Pictured is C. W. Horton's residence.

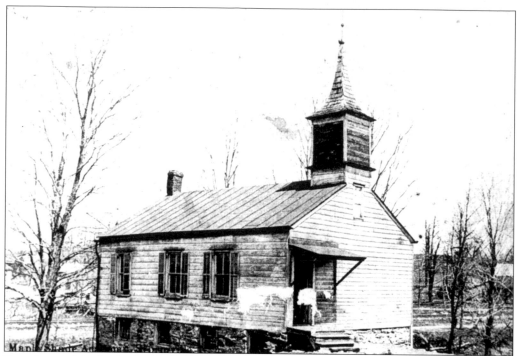

Seen here is Maple Shade Academy in Stormville.

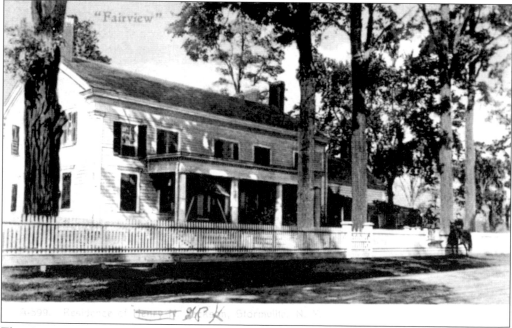

This Storm-Jackson-Tucker house, on Route 216, is significant both because it has been lived in continuously by descendants of the its original owner, Thomas Storm, and because it is one of the town's oldest remaining houses. The lower wing was built in 1743 and the main portion added as the farm prospered. It was given the name Fairview during the 1800s.

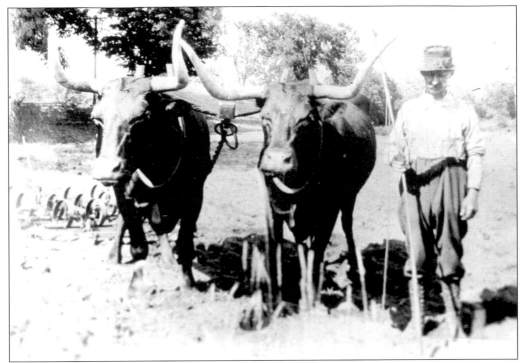

Cornelius Bowne of Stormville, with two fine looking oxen, pulls a harrow rake. In 1925, Bowne claimed that his was the last pair of oxen working on a farm in the town of East Fishkill.

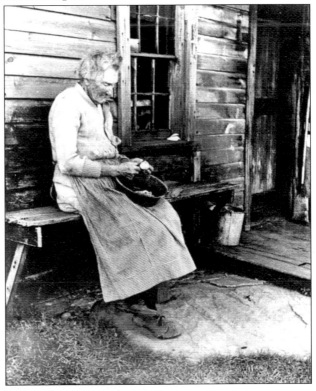

Aunt Abagail (Ballard-Miller) Bush is seen preparing vegetables on the porch of her home. She is typical of a late-19th-century housewife.

The Sylvan Grange Hall/Harpel Hall is seen here on Route 216 near the railroad crossing. This community building was built in 1883 by George Moore Harpel, a wealthy New York City produce and meat merchant, so that his daughters Isabel and Georgina might enjoy community dances. The building fell into disuse and has been converted into apartments.

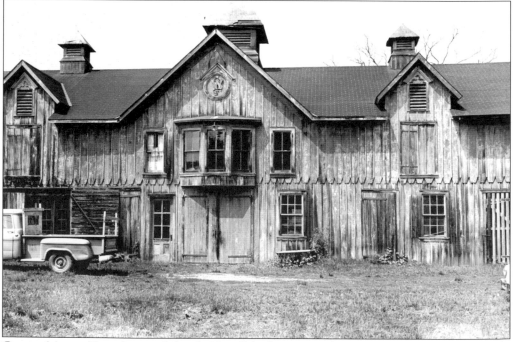

George Moore Harpel owned farmland and built a magnificent 1865 Greek Revival–style residence, known as Maplehurst. The wood barns and outbuildings were also very elaborately decorated, although needing repair when this 1950 photograph was taken.

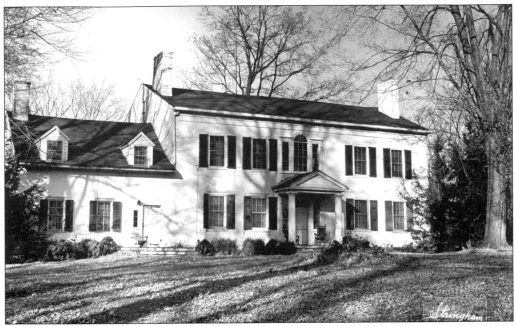

Garret Storm built a house on this site in the mid-18th century. Storm was a known patriot during the Revolution, and one evening, a band of Tory soldiers entered his house and strung him by his feet in the attic. One of his slaves, Epye Schouten, had hidden nearby, and when the soldiers left, she cut Storm down, thus, saving his life. Twenty years later, Storm remembered Schouten in his will and directed his executors to "support her during her natural lifetime."

Many of the local families had slaves to help clear and farm their land. The Storm family slave cemetery is on Phillips Road, 300 yards above the bridge over the creek. It is here that Epye Schouten is buried. A newly reconstructed fieldstone wall encloses the graves marked by boulders. Originally wooden crosses, which have rotted, identified the graves, so the names of others buried there may never be known.

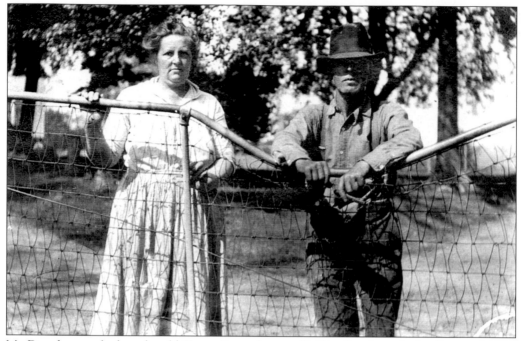

Mr. Donohue worked on the old Garret Storm farm on Phillips Road, just before Banton Moore purchased it. Donohue and his wife, seen here, lived in the brick house during the 1920s and raised their family there.

Wilson Donohue, their son, was born at the farm in 1912 and attended the Old Hopewell School. He recorded on video his memories of attending the one-room school, but sadly he passed away in 2005.

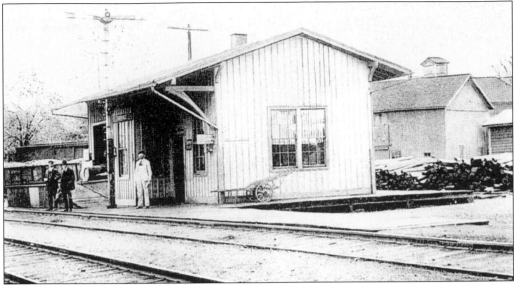

Seen here is the Stormville Railroad Station on the line from Hopewell to Danbury.

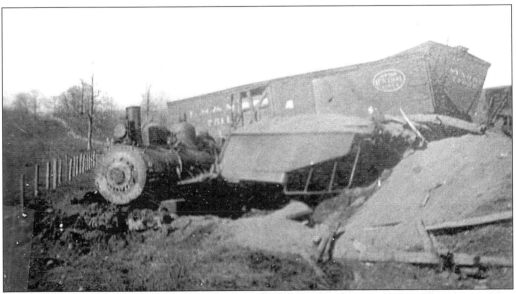

A steam train of the New York, East Haven and Hartford Railroad was involved in a serious wreck at Stormville in 1930.

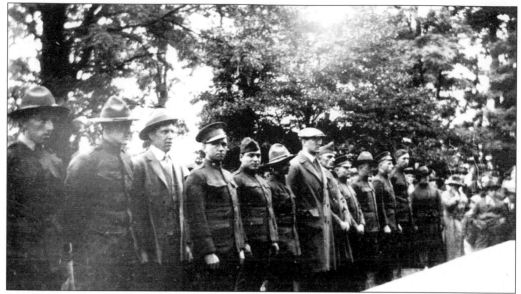

Stormville's soldiers are welcomed home upon returning from Europe at the end of World War I in October 1919. The informal parade was held at the Odd Fellows hall on Route 216. Interestingly, the hall is opposite the 1776 Revolutionary War parade ground at the corner of Stormville Road.

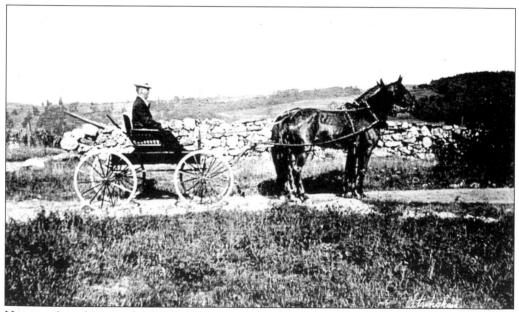

Here is a fine photograph of William Henry Smith in a piano box buggy pulled by a matched pair of horses. One could buy a similar buggy from Sears and Roebuck for less than $50 in 1910.

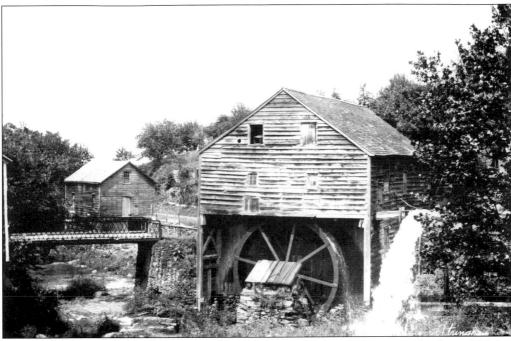

This is the gristmill near Peck Slip (Pecksville). The slowly rotating waterwheel would have been a familiar sight 200 years ago. Many water-powered grist, saw, and plaster mills were located along the creeks and streams in East Fishkill.

The home of E. B. Storm was photographed in 1898. E. B. Storm's wife and children are sitting on the front lawn. The house was built around 1820.

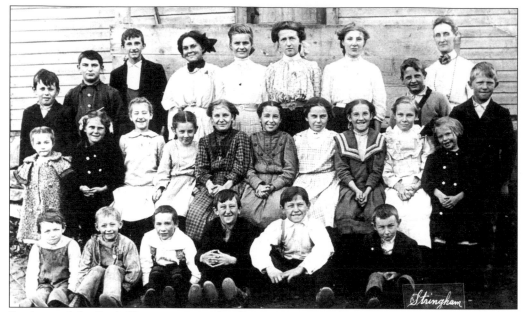

Students of the Peck Slip one-room schoolhouse are pictured in 1920. From left to right, they are (first row) Hansen Lewis, Harold Dailey, Halcox Ballard, Orsie Lewis, George Lewis, and Clayton Lewis; (second row) Gertrude Lewis, Frances Williams, Majore Lewis, Flossie Davis, Clarice Barber, Edith Ballard, Ada Meat, Edith Light, Edith Dailey, and Alice Davis; (third row) Nate Davis Jr., George Griffen Jr., Ernest Smalley, Nellie Williams, Gladys Smalley, Bertha Allen, Mrs. Wilson, Russell Dailey, unidentifed teacher, and Norman Davis Jr.

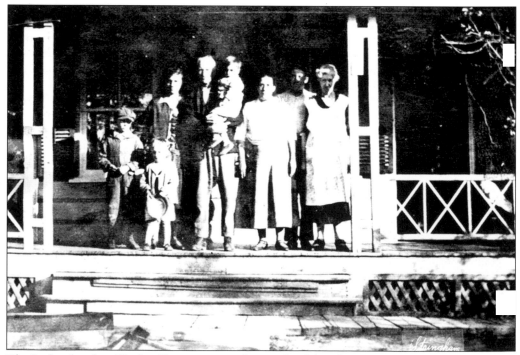

The Lights family of Pecksville are seen on the porch of their house in May 1927.

Six

HOPEWELL JUNCTION

A survey map drawn in 1798 by Henry Livingston Jr. shows only three homes in the vicinity of where the center of East Fishkill is today. At that time, it was part of the Town of Fishkill, and there were orchards and pastures where the A&P now stands.

Hopewell Railroad Station was built in 1873 to serve the Boston, Hartford and Erie rail line, which ran between Beacon and Pine Plains. The station was originally closer to the Hopewell Inn and was moved to its present location around 1905. A tall tower located nearby held water that was used to fill the steam-driven locomotives' water tanks.

Construction of the first rail line through Hopewell was started by the Dutchess and Columbia Railroad Company. The line would run from Dutchess Junction, Beacon, to Pine Plains. When the first train steamed through Hopewell in 1869, it was under management of the Boston, Hartford and Erie Railroad. Later the New York and New England Railroad ran an east-west line from Connecticut through Hopewell to the railroad bridge across the Hudson River at Poughkeepsie. Thus, there were two rail lines crossing at Hopewell hamlet, and the area become known as Hopewell Junction.

The advent of the railroads passing through Hopewell in the later quarter of the 19th century was the incentive for growth of commercial businesses, stores, hotels, and homes around the railroad yard. This caused the town center to migrate from the area around Hopewell Reformed Church to the area around Hopewell Inn. Eventually, the hamlet had its own post office, which made the new name, Hopewell Junction, a fixture.

Throughout this period, there was a thriving agricultural industry, and this benefited from the ability to ship produce to a larger market. In particular, many farms began to specialize in milk production as the train ensured milk could be quickly delivered to the large market in New York City. Borden's Creamery was on the opposite side of Railroad Avenue facing the Hopewell Inn. The plant was constructed in 1901 to process at least 3,000 gallons of milk daily. Milk was brought to the creamery from the local dairy farms to be pasteurized and bottled before being shipped to the city. The milk was transported in insulated box railcars to Dutchess Junction, where it was transferred onto the New York City Railroad. The processed milk was kept cool with ice, which had been harvested from ponds and lakes during the winter. The duck pond behind the Burtis Hotel was a source of ice, as was Sylvan Lake. The creamery remained in business until the 1930s.

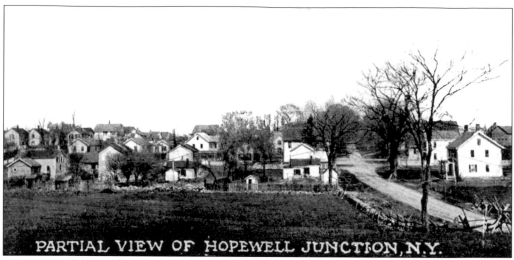

PARTIAL VIEW OF HOPEWELL JUNCTION, N.Y.

Seen here is Hopewell Junction in 1910, looking along Route 82 toward Beekman. The houses in the middle distance are on Route 376. Stone walls topped with a wood stake and rail fence enclosing fields were popular for animal enclosures in the 1800s throughout the Hudson Valley.

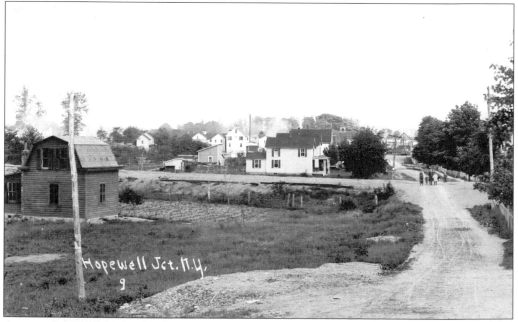

A summertime photograph of Hopewell Junction is seen here when the telegraph and power lines had been erected. The tracks of wagon wheels are visible in the dusty, unpaved road.

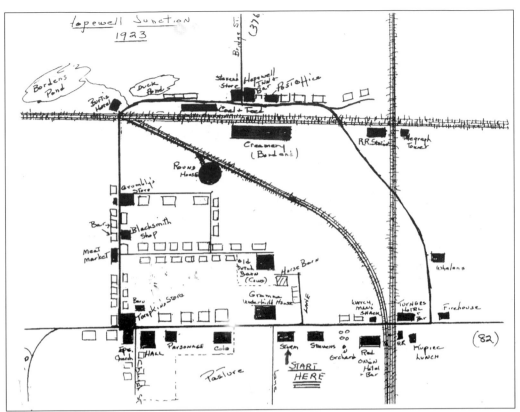

Seen here is Charlotte Dodge's map of Hopewell Junction as she remembered it in 1923. Dodge used the map to illustrate a talk she frequently gave about a childhood walk around the hamlet.

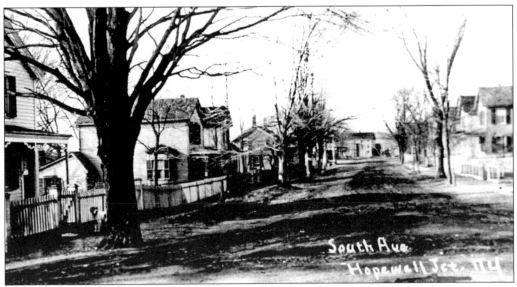

South Avenue was in the center of the hamlet. This was the beginning of a residential community with houses separated by neat picket fences and a tree-lined street to provide shade in summer.

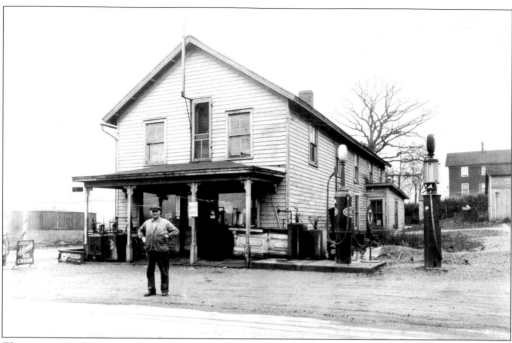

This is a 1920 photograph of Mr. Grumbly's general store, which was on the east side of Route 376. This one-man operation sold everything from butter and ice cream to kerosene and gasoline.

Mr. Grumbly stands ready to serve a customer in his store. It is interesting to note that a pound of peanut brittle cost 29¢, and butter was 60¢.

In 1937, Caplan's gas station stood at the corner of Routes 82 and 376. Although no longer used as a gas station, the buildings remain today.

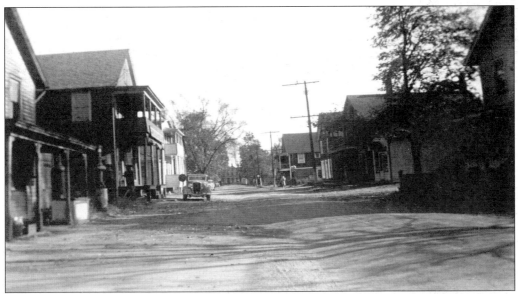

Hopewell hamlet is seen here on Main Street (Route 376) around 1930. On the left is Grumbly's Store, Schaffer Store, and Kennedy House. On the opposite side is the Biker House, the shoe repairer, Burn's Hotel, Max Uhle's Bar, and Mel Quick's Store. Many of these buildings still stand today.

The Beasmer family poses on the porch of the Burn's Hotel on Route 376 in Hopewell Junction hamlet. The building has since been demolished.

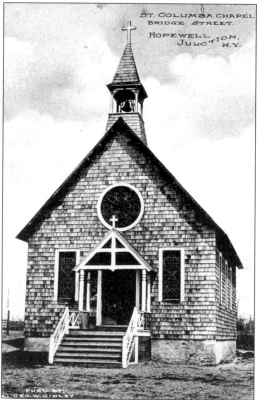

ST. COLUMBA CHAPEL
BRIDGE STREET.
HOPEWELL
JUNCTION N.Y.

St. Columba Chapel on Bridge Street is now a Union Hall.

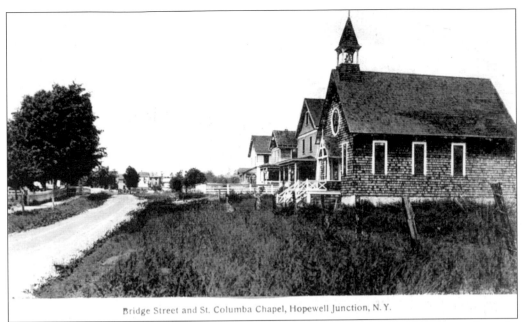

Bridge Street and St. Columba Chapel, Hopewell Junction, N.Y.

This view looking north shows Bridge Street in Hopewell Junction. The building on the right is the original St. Columba Church.

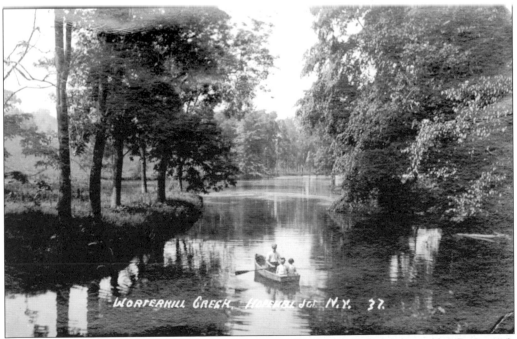

WORTEAKILL CREEK, HOPEWELL JCT N.Y. 37.

The source of Wortlekill Creek (note the different spelling) is at Arthursburg, and it flows south into the Fishkill near the town hall. It was once used for pleasure boating.

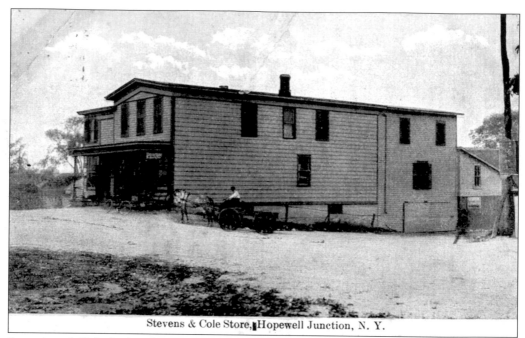

Stevens & Cole Store, Hopewell Junction, N. Y.

Stevens and Cole feed and general merchandize store, now known as Geek's Place, stands on the sharp bend at Route 376.

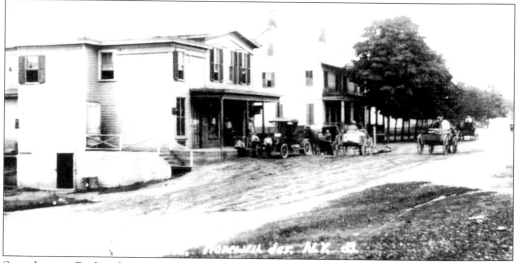

Seen here is Railroad Avenue. An early automobile is parked in front of Stevens' store. On the opposite corner is the Hopewell Inn. Horse-drawn wagons are transporting cans of milk to Borden's Creamery. The post office was located on the left side of the avenue.

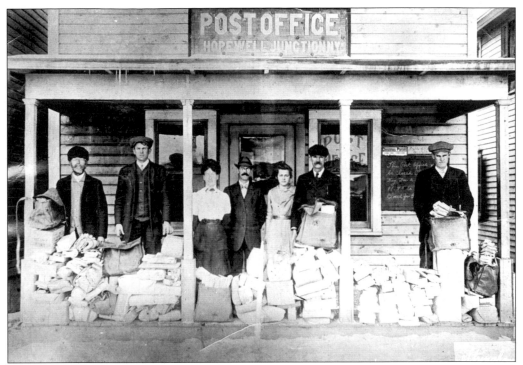

The post office was located in a building, now a residence, on Railroad Avenue. Standing from left to right are Isaac Vumilyea, Walton Travis, Lois Vumilyea, George Gidley, Florence Chase, Everett Wright, and Allin Burnett with the Christmas mail in 1914.

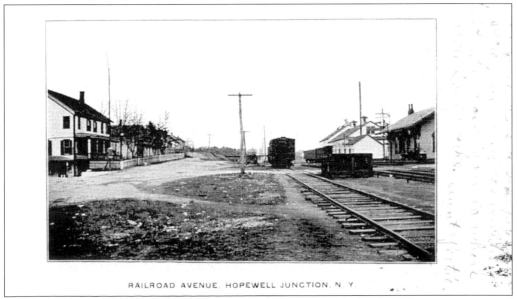

RAILROAD AVENUE, HOPEWELL JUNCTION, N. Y.

The hamlet clustered around the railroad yard. This picture shows the station in its original location, opposite the Hopewell Inn. In the background is Borden's Creamery.

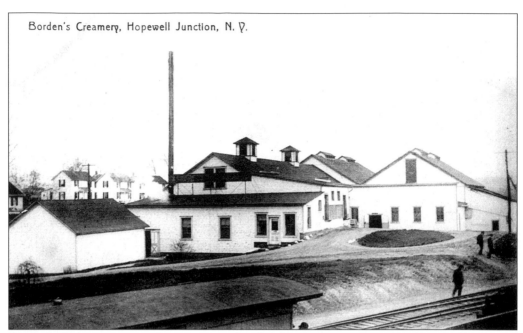

Borden's Creamery, Hopewell Junction, N. Y.

Borden's Creamery was on the opposite side of Railroad Avenue facing the Hopewell Inn. The plant was constructed in 1901 to process at least 3,000 gallons of milk daily. Milk was brought to the creamery from the local dairy farms to be pasteurized and bottled before being shipped to the city.

Bry Dain's, now Williams, lumber yard in the 1930s is seen with many rail tracks running alongside the yard. This illustrates how busy the rail junction became at its peak of operation. Some tracks remain, although regular train service ended in 1935.

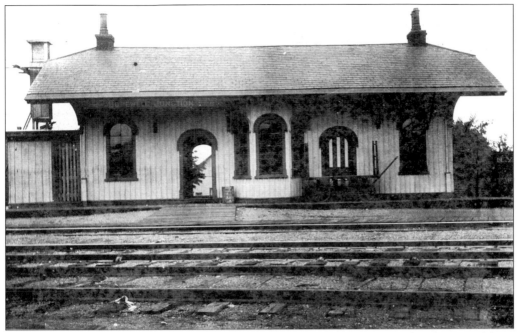

Hopewell Railroad Station was built in 1873 to serve the Boston, Hartford and Erie rail line, which ran between Beacon and Pine Plains. The station was originally closer to the Hopewell Inn and was moved to its present location around 1905. The picture shows the building in its present location. The tall tower in the background held water that was used to fill the steam-driven locomotives' water tanks.

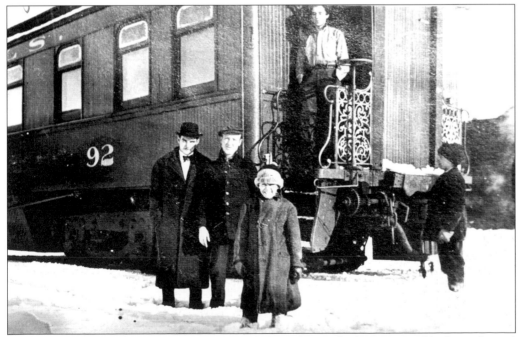

Hi Henry's Minstrel Company became stranded in Hopewell, due to snow blocking the rail tracks. From left to right are Tom Colgan, Bob Hughes, and Ellie Hughes.

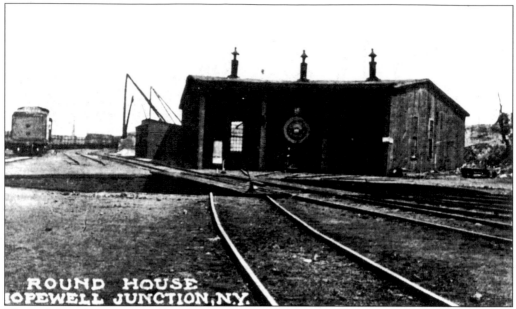

The rail line from Hopewell to Danbury had to pass over Stormville Mountain, and the locomotives needed assistance to take the trains up the steep inclines. The massive pusher engines were kept in the roundhouse. The structure burnt down in 1949.

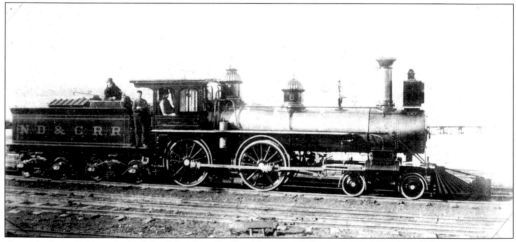

A typical steam engine of the Newburgh, Dutchess and Connecticut Railroad that saw service on the Hopewell line in the early days of the railroad is seen here. Forrest B. Annis is the engineer in the cab.

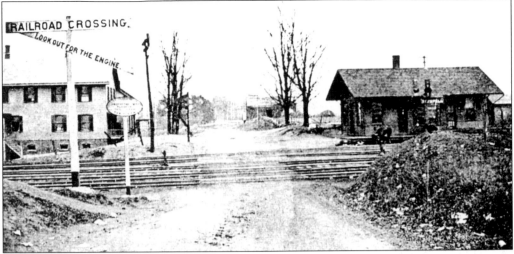

The at-grade railroad crossing on Route 82 (by Williams Lumber) is seen here around 1900. Turner's Hotel is on the left, and on the right is the house station. A flagman would come out of the station to stop traffic when a train was due to pass. The crossing was replaced by the road bridge in 1935.

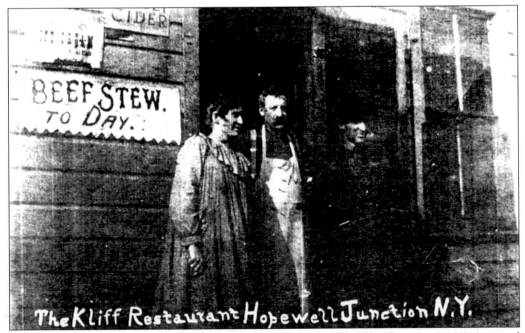

The Kliff Restaurant was located opposite Turner's Hotel on Route 82. The restaurant was owned and operated by John and Saidi Kliff (left), who are standing outside the restaurant entrance with a customer. John Kliff, in the center, was murdered in the restaurant on January 24, 1909.

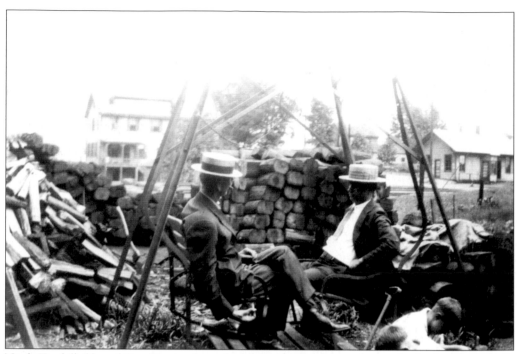

Noah Teed (left) and Ray Finger, dressed in their Sunday best, relax in the backyard of Teed's house, which backed onto the rail tracks. Turner's Hotel is in the background.

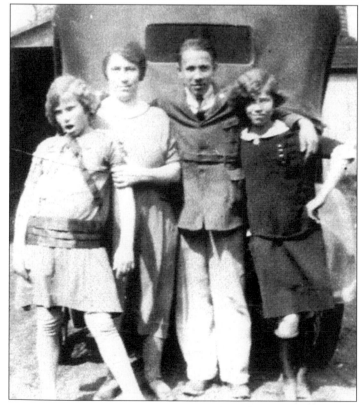

Four members of the Teed family pose for the camera in front of the 1919 Dodge family car. From left to right, they are Constance, Mabel, Steven, and Irene.

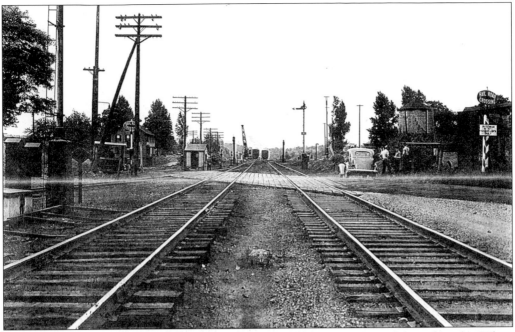

Turner Avenue ran from the Hopewell Inn to Beekman Road and crossed the rail tracks. When the Route 82 overpass, seen under construction in the distance, was completed, Turner crossing was closed. It remains closed, even though there is no service on the line.

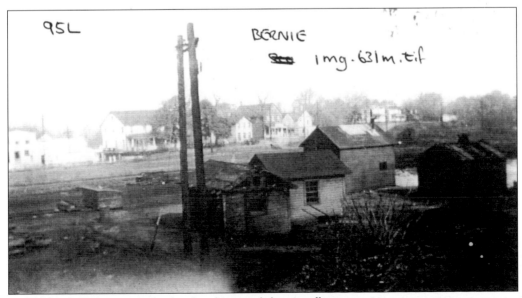

Seen here is Turner Avenue after fire destroyed the roundhouse.

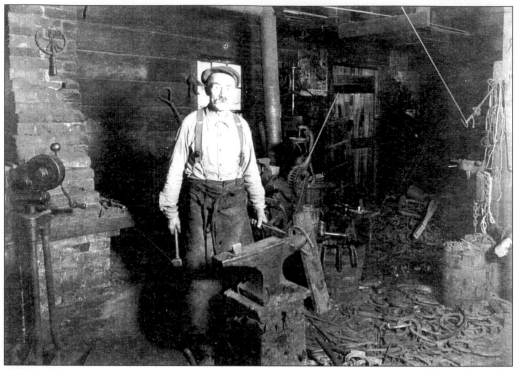

George H. Pascoe is seen here working in his blacksmith shop, which was on Route 376 opposite Mid-Hudson Pump. Pascoe was the late George Bailey's grandfather.

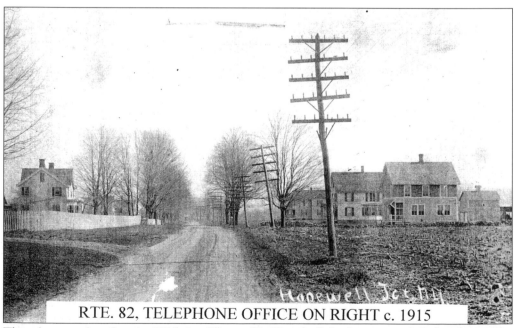

RTE. 82, TELEPHONE OFFICE ON RIGHT c. 1915

This photograph, taken in 1915, is of Route 82, Hopewell, looking toward Arthursburg. The telephone office is on the right. Observe all the telephone lines, which carried the signals from New York City to Albany. George H. Pascoe lived in the second house on the right.

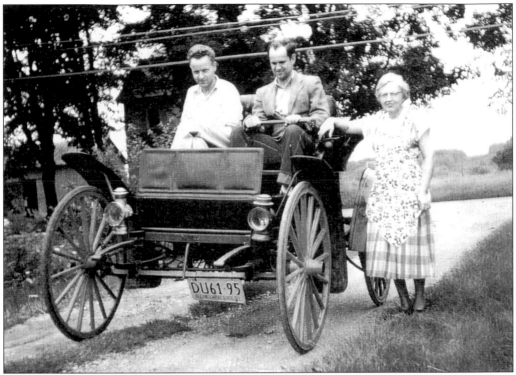

George Bailey (left) and Cole Palen are sitting in a 1905 Sears Runabout. Standing is Dellaphine Bailey, George's mother. Palen, an aircraft enthusiast, flew many of his own antique aircraft at the historic air shows that he promoted at Rhinebeck Aerodrome.

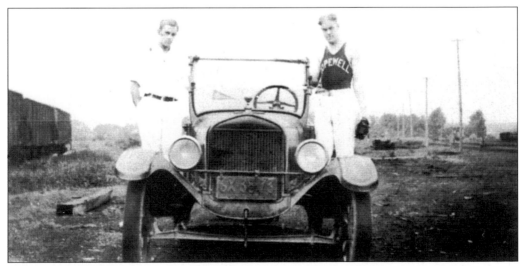

Benny Taylor (left) and Harold Storm are seen after playing baseball for the local team.

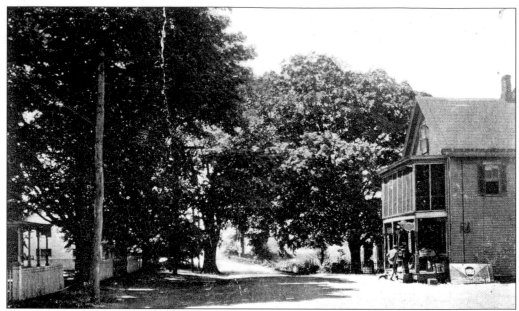

This photograph was taken looking along Route 82 from the Hopewell Antique store. The picket fence and house on the left are next to Frankie's Superette. The building on the right with the enclosed porch was at the corner of Route 376 but was later moved farther along the street.

The original Episcopalian church in Hopewell Junction has been converted into Frankie's Superette.

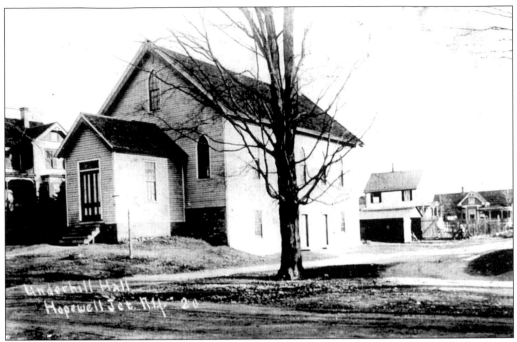

Underhill Hall, also known as Emmadine Hall, is on the corner of Church Street. It has been converted to become the Hopewell Antique Center.

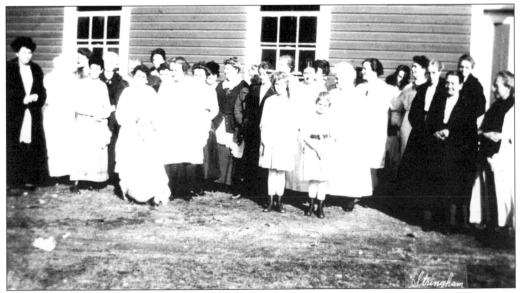

Red Cross volunteers are gathered outside Emmadine Hall, sometime during World War I.

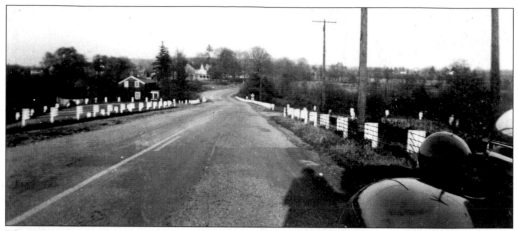

This photograph is of Beekman Road, as seen from the top of the Route 82 railroad overpass. Mr. Van Norstrand's house is on the left. This house was raised from its foundations and moved a half mile to a new site on Beekman Road.

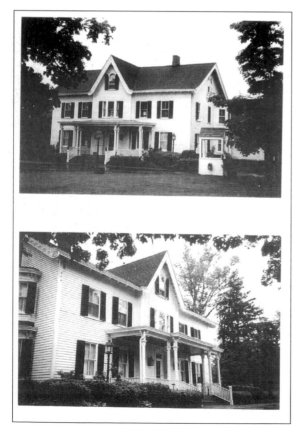

The Van Wyck-McHoul house, now a funeral parlor, was built in 1750 by Richard Van Wyck on land purchased from Madam Brett. Van Wyck's son, Theodorus, was a major in the Revolutionary War. In 1885, the house was sold to the Rapalje family, who transformed it into a then fashionable vernacular Italianate-style house.

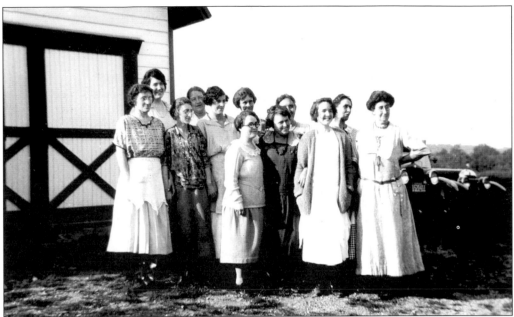

Members of the Lady Auxiliary of Hopewell Hose Company No. 1 stand by the painted barn, which was Hopewell's first firehouse. The 1921 Ford Model T fire truck was kept in the barn until the structure was torn down when the Route 82 bridge was built.

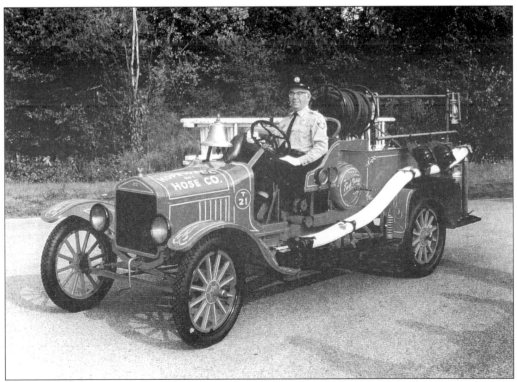

Jim Lund drives the town's first fire truck, now beautifully restored. According to rumor, the first time the vehicle was called to a fire, it broke down and never made it.

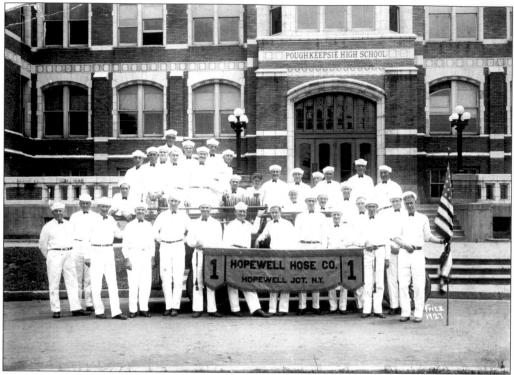

Hopewell Hose Company's firemen, in their "dress whites," are seen attending a parade at Poughkeepsie in 1927.

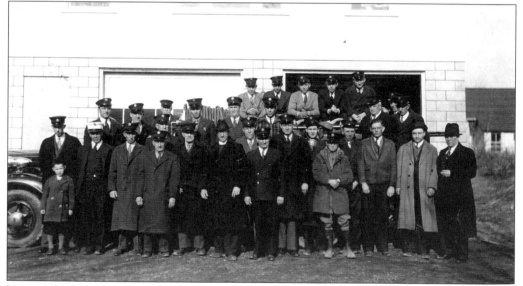

Hopewell's next firehouse was on Church Street and is now used as a dance studio. The men in this 1940 photograph are, from left to right, firemen (first row) A. Way, D. Way, P. Doran, M. Way, H. Christinger, F. Van Norstrand, Father Donovan, F. Valk, H. P. Bailey, G. Kershaw, C. Lasher, J. Salls, and F. Way; (second row) J. Brewster, R. Valk, J. Burns, and B. Doran; (third row) G. Brugzel, E. Brugzel, C. Ross, Nat. Gobel, D. Maloney, unidentified, J. Polemus, and H. Kelly; (fourth row) C. Meade, unidentified, Bill Ross, E. Kelly, D. Dorwood, and unidentified.

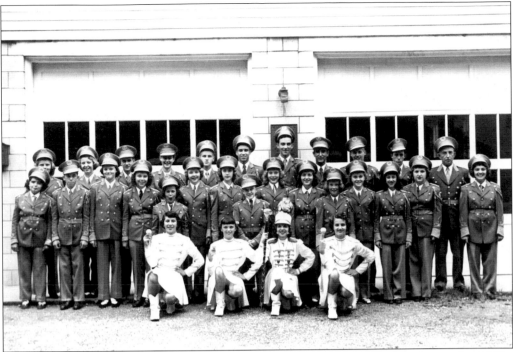

Hopewell Hose Company No. 1 had a fife and drum corps for several years during the 1940s. This is the 1948 team, with baton twirlers, standing in front of the old firehouse on Church Street. Monty Way, second from the right, was the corps leader.

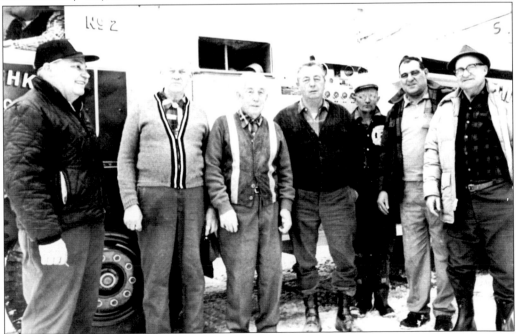

The senior members of Hopewell Hose Company No. 1 pose for a photograph in the 1960s. From left to right are Larry Russell, Elton Bailey Sr., Monty Way, John Ossenkop, Chief Lou Knapp, Joseph Caruso, and Ray Hickman Sr.

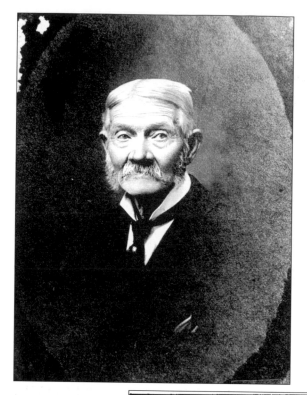

William N. Anthony was publisher of the *Hopewell Junction Weekly* news sheet from June 1899 until December 1900. An interesting comment from a January 1899 edition: "There is a healthy outlook for the growth in our village and our citizens who have land will no doubt find it a good investment to build a few houses."

There were several hotels in the town, and this advertisement, without a street address, does not identify which Hopewell Junction hotel this is.

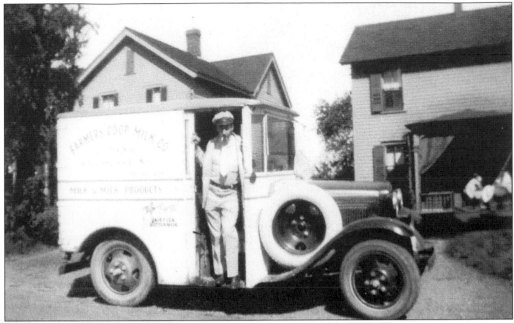

Charlie Teed delivers milk to homes in Hopewell.

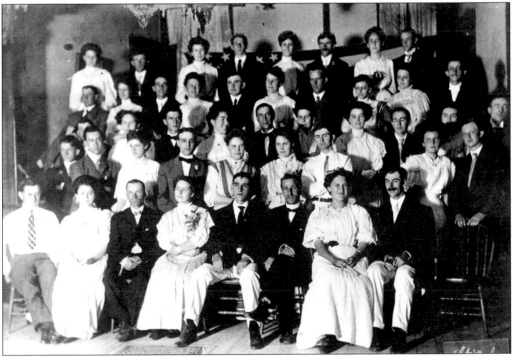

This smartly dressed gathering of the town's young people in the 1920s was probably for a special dance at Underhill Hall. Among the attendees is Charlotte Underhill (lower right), sitting with William T. Storm.

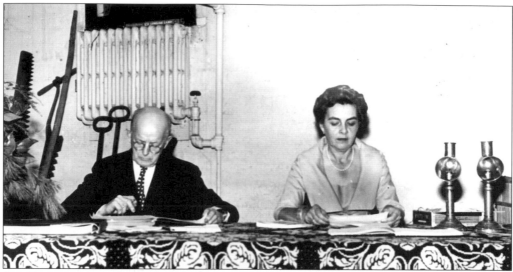

Seen here are George Kershaw and Charlotte Finkel, charter members of the East Fishkill Historical Society. The society began in 1960, when members held monthly meetings in each others' homes. The society received its New York State charter in 1962.

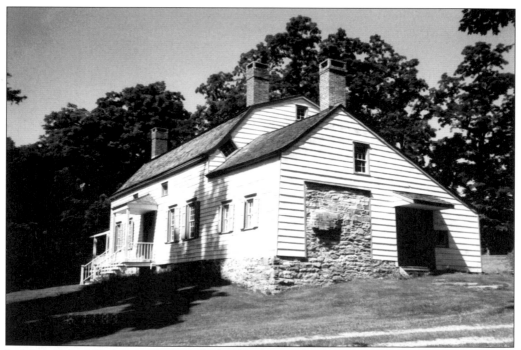

In 1974, Gustav Fink gave the Brinckerhoff-Pudney-Palen house to the East Fishkill Historical Society. The oldest part of this Dutch-style farmhouse was built around 1750 on land purchased by Dirk Brinckerhoff from Madam Brett in 1718. The Brinckerhoffs built the gambrel roof section around 1785. Today it is furnished with locally donated furniture and houses collections of documents and artifacts related to the town.

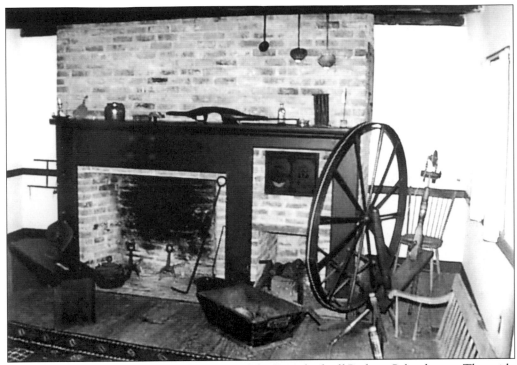

Seen here is the kitchen in the 1750 wing of the Brinckerhoff-Pudney-Palen house. The wide fireplace was used for cooking, and a beehive oven on the right was for baking bread and pies. The large "walking" spinning wheel and the wood dough box were once used in local homes.

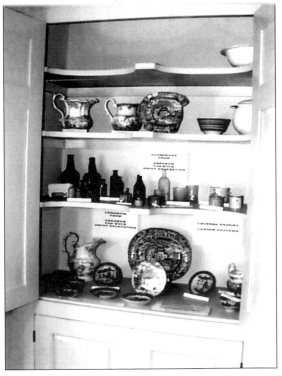

IBM funded professional archeological digs at the sites of the Theodorus (John Jay) and Abraham Van Wyck houses in 1984 before they were eventually dismantled to make way for facility buildings. The artifacts that were uncovered are housed in the Brinckerhoff-Pudney-Palen house. A selection of pottery and glassware dating back two centuries is displayed at the house.

Griffen's Tavern on the banks of Sprout Creek, adjacent to Royal Carting, was built around 1735, alongside the Revolutionary Road from Hartford to Fishkill Landing. It had been "improved" by several owners, and it looked quite different from its original architecture when this painting was created by Oliver Waldo in 1960.

The Bergers purchased the property and set about restoring the structure to its 18th-century square stone tavern configuration. The building had been frequented by Washington, Lafayette, Putnam, and Stuben during the Revolutionary War time. This is the restored building, before it burnt in 1990, leaving only the stone walls standing.

Seven

FISHKILL PLAINS

History relates that Mohegan Indians occupied a camp at Fishkill Plains. They had a friendly relationship with the early settlers and remained in the area until they, together with the Wappinger tribes, moved to Stockbridge, Massachusetts, in 1756.

Fishkill is a translation of the Dutch word *Vis-kil*, or "fish creek." As the land along the Sprout Creek is fertile and flat and is also bounded by the Fishkill Creek, it is not surprising that the surrounding hamlet would become known as Fishkill Plains.

According to historian Henry D. B. Bailey, the first family to settle at Fishkill Plains was the Montfords, who came from Flatlands, Long Island. Peter Montford (1711–1791) and his wife built a temporary shelter on Sprout Creek in 1735 and, later, a stone house, which took two and a half years to build.

In 1722, William Verplanck, a descendant of one of the Rombout Patent holders, came down from Albany. He built the dam across the Sprout Creek and a mill to do general grinding. During the Revolution, a great deal of grain was ground at this mill for the troops at Fishkill. In 1741, a road had been opened from the mill to the Hudson River to allow wagons to transport grain sacks to Farmers Landing, New Hamburgh, for shipment by sloop down the river.

Phillip Verplanck Jr. came up from Westchester and built the Dutch-style farmhouse on the opposite side of the creek to the mill, which he then owned. This gambrel roofed brick house is one of only two remaining in the town and has the date 1768, marked by black headers set in the west gable. A hundred years passed with the mill under the management of the Verplancks.

In 1828, Col. Richard Van Wyck purchased the property, and it has remained in his descendents' families ever since. The first mill burnt down in the 19th century and was replaced immediately by an updated design. This mill, then known as the Stringham Mill, continued in operation until the late 1930s when it finally closed. All that remains of the mill are the two concrete silos. The railroad ran through the Stringham Farm and the station, although officially Fishkill Plains was referred to locally as Stringham Station. Alongside the station was an icehouse to cool the milk cans before loading onto the train, and there was a feed store close by. When farming ceased, the early Dutch barn was dismantled and moved to the Mount Gulian Historic Site in Beacon, the original Verplanck homestead.

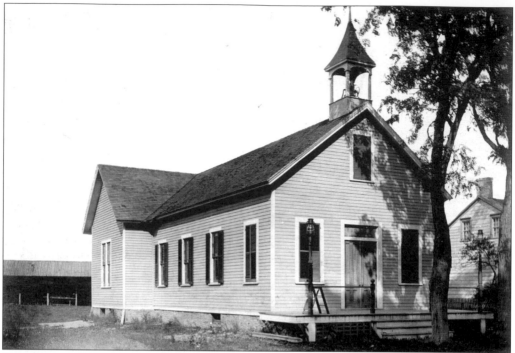

Fishkill Plains Union Chapel was built in 1882 by voluntary labor, subscription, and gifts. This T-shaped building stands on Route 376 and still retains the original stained glass windows and small belfry. The carriage shed for the congregation's horses and buggies is visible behind the chapel. Religious services stopped in the middle of the 20th century, and it then served as the Fishkill Plains Community Library until 1980. It is currently the home of the Sons of Italy.

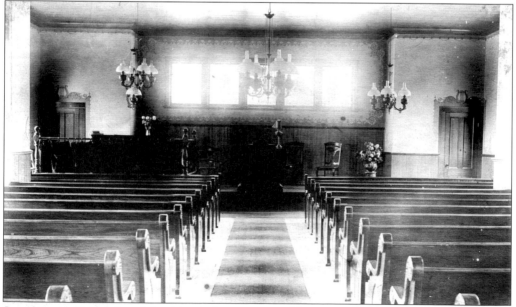

Seen here is the interior of the chapel when it was used for services. Oil lamps provided lighting, and the ornately carved pew ends are clearly visible. It served the local community for almost 80 years and only closed when a new church was built.

J. Lounsbury's farm, known as Kirkwood, was located in the Swartout District on the east edge of the town. The district derived its name from General Swartout, a Revolutionary War soldier, whose house still stands on All Angels Road. The photograph is identified as "Anna, Carrin, Velda and Blanche taken from Sand Hills showing Grandpa Lounsbury's farm."

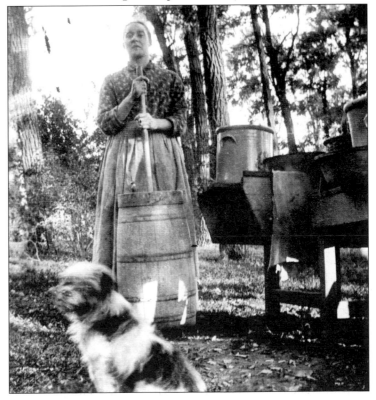

Mrs. Peter Schleuter is seen churning butter in the grounds of the Theodorus Van Wyck house. Milk was poured into the wooden barrel, and the dairymaid laboriously worked the plunger up and down until the milk fat coagulated into butter. Many farms had small treadmills powered by a dog or goat to power butter churns. The East Fishkill Historical Society has a treadmill removed from an early farmhouse in Shenandoah.

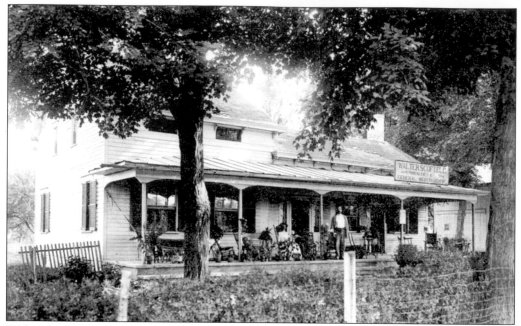

Walter Scofield opened his general store business at one end of his home on Route 376, near Van Wyck Junior High School. The one-and-a-half-story house was built around 1820 and is still occupied.

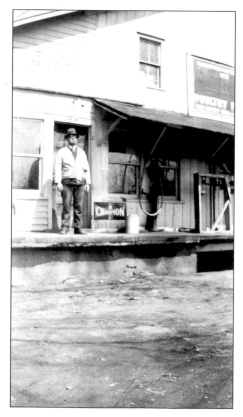

As the business grew, Walter Scofield moved into a purpose-built feed store with a loading platform. The new store was in front of his house. A typically frugal businessman, he moved the original store sign onto his feed store.

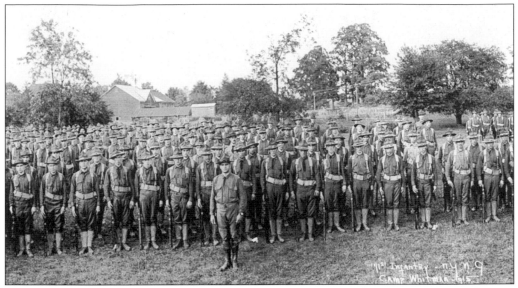

The fields along Lake Walton Road were turned over to the army for the Camp Whitman (named after Governor Whitman) training ground at the start of World War I. The 71st Infantry New York National Guard camped in bivouac tents and trained here before being sent to Europe. This is a section of the company on parade in 1915.

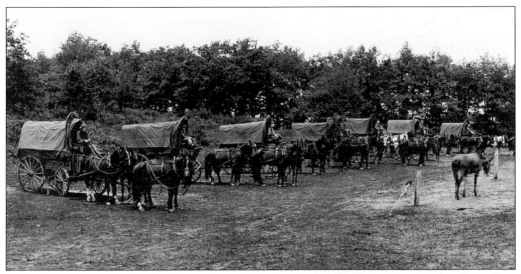

As well as training infantrymen at Camp Whitman, a supply division team was formed to provide logistical support for the troops. In 1915, horses were still used for transporting army supplies. This picture shows some of the wagons, each drawn by a team of four horses. The entire division comprised 20 wagons and 80 horses.

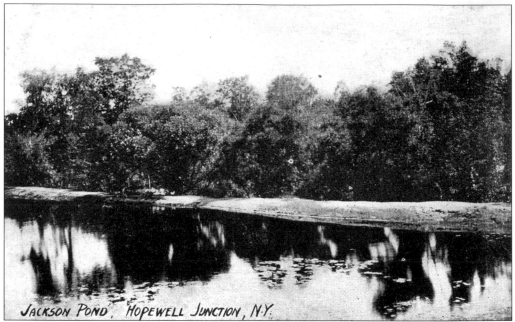

In 1900, the Jackson family farmed the fields around the lake, which was then known as Jackson's Pond. When the Jacksons moved on, the name was changed to Lake Walton.

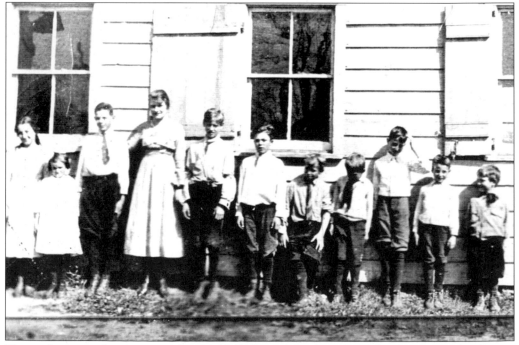

The students seen here are attending Fishkill Plains School in 1918. The one-room schoolhouse had been moved in 1880 to this site and renovated. From left to right, they are Edith Bagley, Gladys Hicks, Carl Kelly, teacher Mae MacLaurer, Gil Bailey, Eddie Scofield, Charles Bailey, Donald Bailey, William Ossenkop, John Ossenkop, and L. Keeser Stringham.

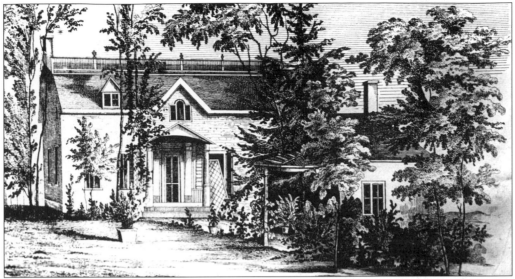

Phillip Verplanck Jr. built this brick house for his bride in 1768 and marked the date with black bricks in the west wall. The house was sold to Col. Richard Van Wyck in 1828 and has been occupied by his descendents ever since. The house is one of only two remaining Dutch-style gambrel roof houses in East Fishkill. The house is wonderfully preserved and retains many of its original architectural features.

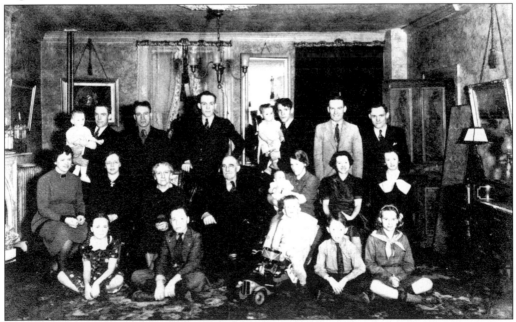

Seen here is a 1939 Stringham family portrait. From left to right, they are (first row) Suzanne, George Lauder, Alfred (James's son), Edward Jr., and Edward's daughter; (second row) Gertrude Stringham, Helen (George's wife), matriarch Susan Varick Van Wyck Stringham, patriarch Edward Bannes Stringham, Charlotte (James's wife) holding Mabel, Harriet, and Keever's wife, Adeline; (third row) Varick Van Wyck Stringham holding Edith, George Lauder Stringham, Richard Verualan Stringham, James Alley Stringham (holding baby), Edward Bloodgood Stringham, and L. Keever Stringham.

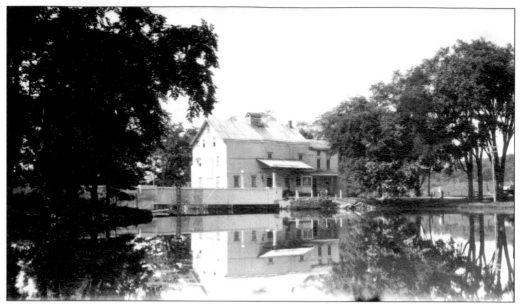

Phillip Verplanck Jr., a descendent of one of the three Rombout Patent holders, built a gristmill, or a sawmill, on Sprout Creek in 1722. The mills stood on this site for more than 200 years until they became uneconomical to operate in 1930s. Stringham's Mill is reflected in the still waters of the millpond.

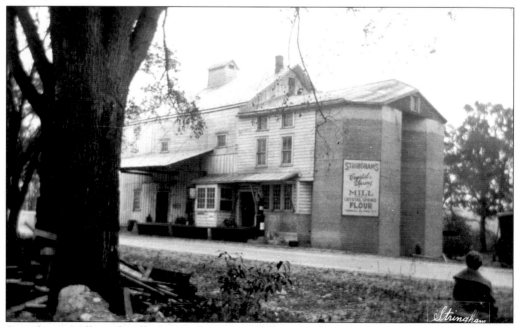

Stringham's Mill was locally famous for its special flours, such as the Crystal Spring pancake mix.

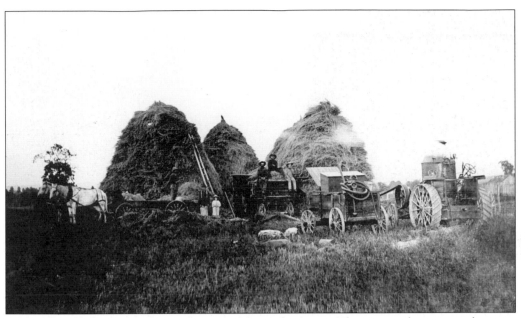

Mechanization began on farms at the end of the 19th century. This picture shows an early steam engine powering a belt-driven threshing machine in East Fishkill. The piles of barley are ready to be fed into the thresher. Alongside the steam engine is a water wagon, which provided water for the engine boiler as well as being available to quench the occasional straw fire caused by sparks from the firebox.

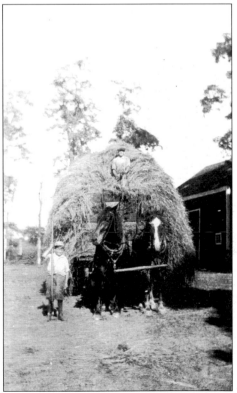

Bringing in the hay, Varick Van Wyck Stringham is seen driving the team of horses.

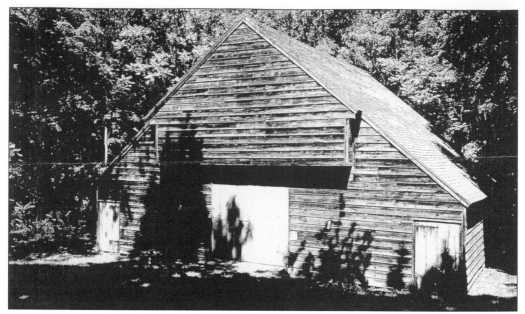

Few Dutch barns from the pre-Revolutionary period survive in the Hudson Valley, and there are still two remaining in East Fishkill. One is behind McHoul's funeral home, and the other is on Route 52 opposite the Highway Department. Phillip Verplanck Jr. built a Dutch barn by his mill on the Sprout Creek. It was particularly unusual having a cantilevered gable, extending out 18 inches. Not only did the overhang protect the doorway, but it allowed ventilation of the upper hay storage. The barn was dismantled and rebuilt at the Mount Gulian site in Beacon.

Col. Richard Van Wyck bought the Verplanck farm in 1828. He served with distinction in the War of 1812, and his descendants continue to live in the farmhouse to the present day.

Pictured is a J. B. Chatterton's, Florist and Plant Nursery business card.

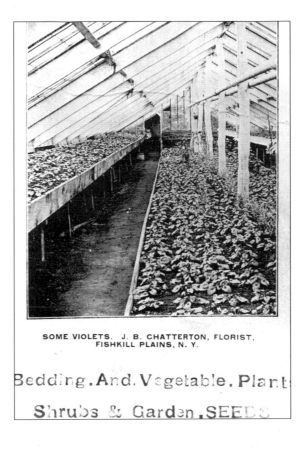

SOME VIOLETS. J. B. CHATTERTON, FLORIST, FISHKILL PLAINS, N. Y.

Bedding.And.Vegetable.Plant

Shrubs & Garden.SEED

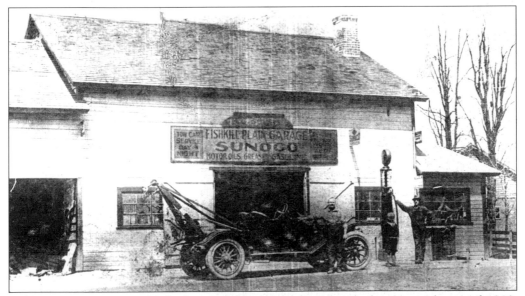

Mark Scism, owner of Fishkill Plain Garage, is shown standing by his tow truck around 1910. His garage was located on Route 376 near Robinson Lane.

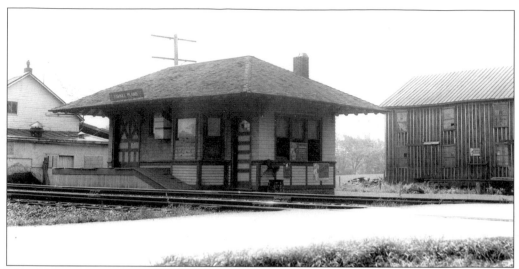

The Fishkill Plains Railroad Station, locally known as the Stringham Station, is seen here. The Farmer's Cooperative Creamery was located next to the station. Farmers would bring their milk cans to be shipped by train to the city. The icehouse to the right was filled with ice that was cut from the millpond in winter and used to cool the milk. The station no longer exists.

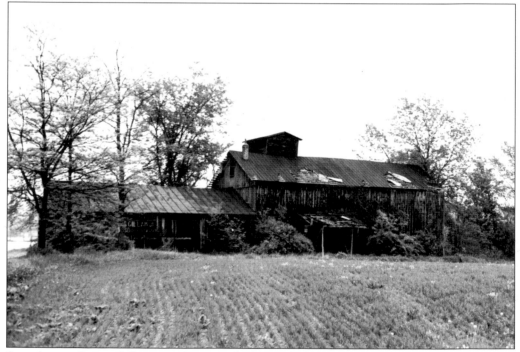

Seen here is Burns Gilham seed store, which stood alongside the railroad where it crossed Route 376. It burnt down around 1945.

Eight

Sylvan Lake

The lake known as Sylvan Lake is in the town of Beekman. Part of the hamlet known as Sylvan Lake, however, is within the town of East Fishkill and, so, is worthy of inclusion in this book. This naturally formed lake is believed to be 140 feet deep in the middle. It was earlier named Silver Lake, but over time, this has been corrupted into Sylvan Lake.

Iron ore was discovered nearby, and workers came from Ireland to dig the ore from the mines. A railroad spur connecting Sylvan Lake to Hopewell was inaugurated in 1869, primarily to move the ore from the mines. A few years later, this line was extended eastward another four miles to transport ore to be smelted in an iron furnace, now in ruins, in Clove Valley.

The men, who came to work in the mines, began by staying in boardinghouses. However, their families, from the home country, soon followed, and it did not take long for them to establish an Irish community around the lake. Many of their descendents still live in the area. The Sylvan Lake Hotel was a popular gathering place for the workers and travelers alike, to relax and enjoy the scenery. Unfortunately, mining operations in this area became uneconomic when large iron deposits were discovered in the Midwest, and the local mines eventually closed. The Sylvan Lake Hotel was destroyed by fire around 1910 and was not rebuilt, thus, ending an era.

In the early 20th century, people in the city began discovering the rural character of Dutchess County, and several summer camps were built around the 100-acre lake and on the site of the old hotel. Generations of young people have spent their summer months at these camps, with names like Kinder Land, Kinder Ring, Camp Carlisle, and, naturally, Camp Beekman. The camps provided outdoor activities like soccer, tennis, and canoeing on the lake, as well as arts and crafts classes. The camps are still open during the summer to give an opportunity for city kids to experience life in the country.

This chapter completes the look at bygone images of East Fishkill. The photographs have recorded a much different town than that of today. A century ago, the automobile was in its infancy, and the roads were unpaved. Agriculture was still the main industry, although there were better paying jobs working for the railroad. Today East Fishkill is a town in transition; houses are being built at a rate unthinkable a few years ago. Traffic congestion is becoming a problem, and the rural character of the area is rapidly disappearing. Enjoy these glimpses into a past, which someone took the time to record and preserve.

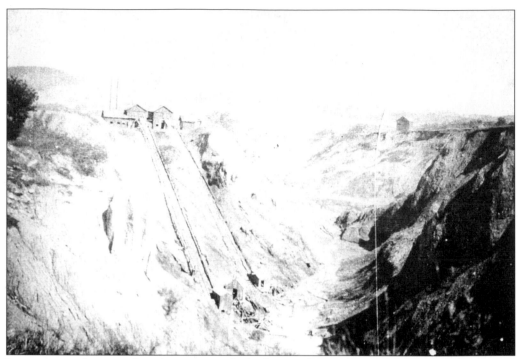

Iron ore was discovered in the town, with the largest deposits being in the northeast corner. Workers came from Ireland to work in the mines. Ore was smelted in the furnace at Beekman, and some was shipped out on the railroad. When mining became uneconomical, the mine was abandoned and filled with water.

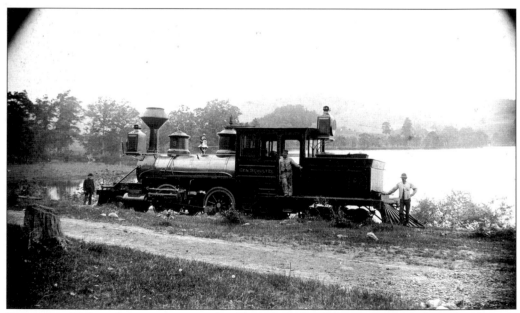

The *General Schutzer* steam engine on the Clove Branch rail line at Sylvan Lake is seen here in 1885. Trains carried iron ore from the mines.

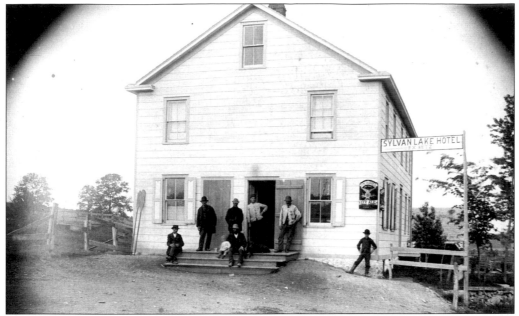

A group of workers is relaxing on the steps of Sylvan Lake Hotel after a day's labor in the mines around 1900. The signs are advertising Hincliffes XXX Ale. The name F. X. Betz suggests that Betz was the proprietor.

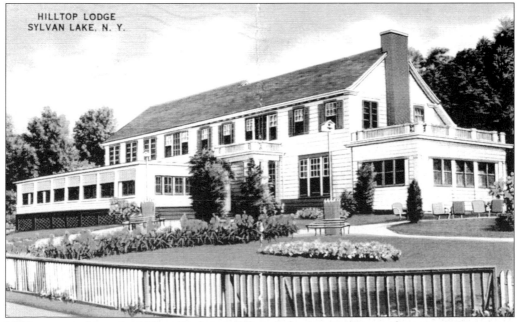

HILLTOP LODGE
SYLVAN LAKE, N. Y.

Half a century later, the Hilltop Lodge on Sylvan Lake was catering to the prosperous summer visitors from New York City. Aside from horse riding, golf, tennis, and table tennis, the hotel promoted free boating on the magnificent Sylvan Lake.

An early photograph, taken around 1900, shows boating and fishing on Sylvan Lake.

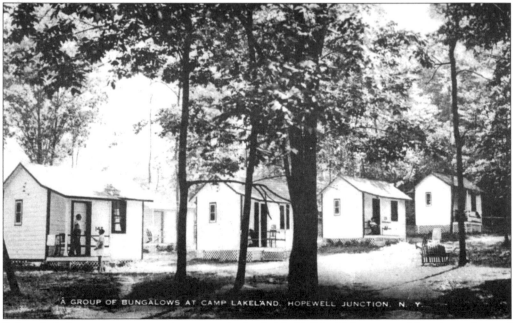

A GROUP OF BUNGALOWS AT CAMP LAKELAND. HOPEWELL JUNCTION. N. Y.

Sylvan Lake became a summer camp venue in the first half of the 20th century. Many bungalow and camp communities were established around the lake. This is a group of cabins at Camp Lakeland.

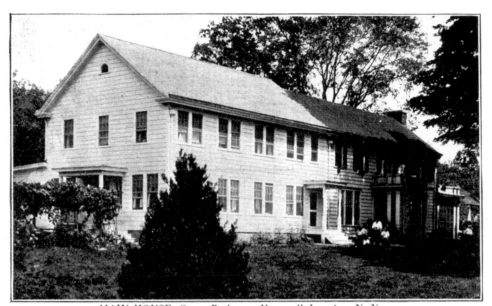

MAIN HOUSE, Camp Beekman, Hopewell Junction, N. Y.

The largest camp was called Camp Beekman and had a main dormitory building and large dining room.

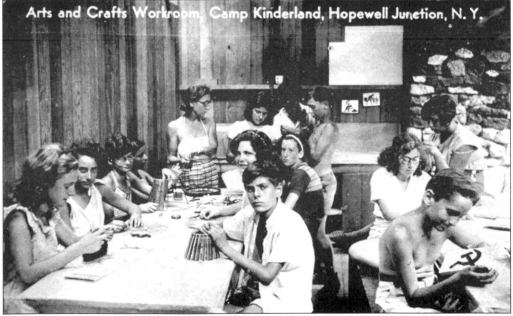

Arts and Crafts Workroom, Camp Kinderland, Hopewell Junction, N. Y.

Not all activities at the camps were outdoors, as seen by the arts and crafts workroom at Camp Kinderland.

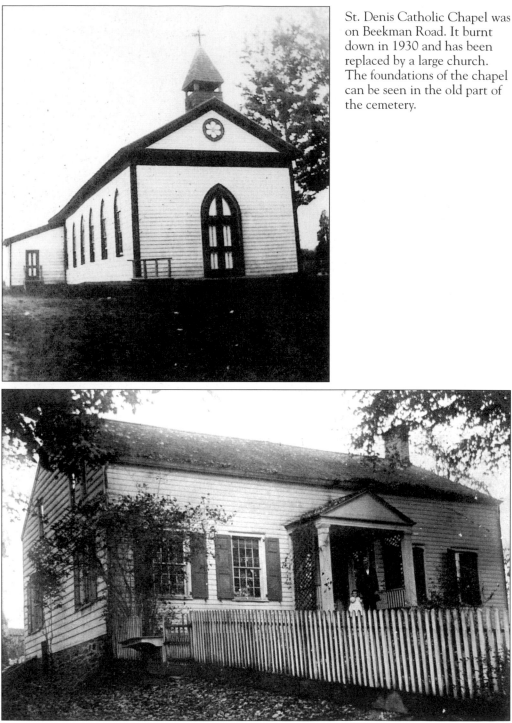

St. Denis Catholic Chapel was on Beekman Road. It burnt down in 1930 and has been replaced by a large church. The foundations of the chapel can be seen in the old part of the cemetery.

In 1867, William Bogardus and Elias Bogardus owned properties in school district No. 9 near Sylvan Lake. A nearby road is named after the family. This is one of the Bogardus homes, probably built around 1800, showing a father and daughter standing on the porch. Note the mounting platform for entering or alighting from a carriage.

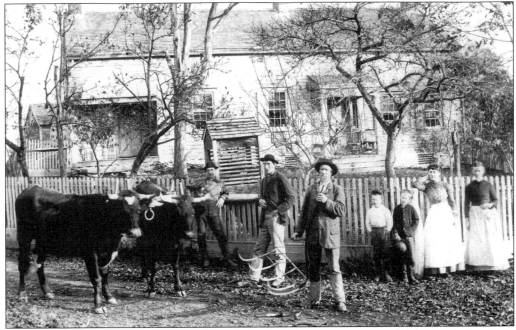

Members of the Kelley family stand on Sylvan Lake Road in front of their homestead toward the end of the 19th century. From left to right are a pair of friendly oxen, sons Martin and James, Martin J. Kelley (born in 1830 in Ireland), sons Thomas and John, daughter Margaret (who later married George F. Miller), and Katherine Flynn Kelley. The Kelleys were married for more than 69 years.

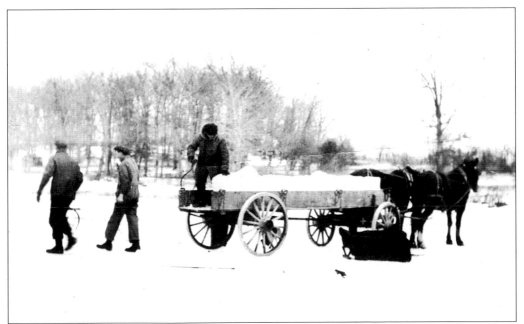

The Phillips and Moore farms harvested ice. Here a wagon is being loaded with ice cakes. A "choke rope" was tied around the horse's neck so that if it fell through the ice, the rope would tighten and close off the windpipe. The horse would float and could be pulled out of the water.

ACKNOWLEDGMENTS

The publication of *East Fishkill* has only been possible because of the many people who searched through their collections of old photographs, postcards, and newspaper cuttings and then allowed me to select pictures for inclusion in this book. I am indebted to the trustees and members of East Fishkill Historical Society for permitting me to use photographs from its cataloged collection, and all royalties from the sales of this book will benefit the society.

A source of early town pictures is the late George Bailey's collection, and I am grateful to his widow, Bettie, for sharing his collection. Vern Jackson provided pictures of the Shenandoah hamlet, and his cousin Jane Morris offered pictures from her family album. Ed and Diane Hickman let me draw from their comprehensive collection. I particularly thank Robert Morgenthau for providing pictures of his mother riding with Eleanor Roosevelt and of his father electioneering with Pres. Franklin Delano Roosevelt.

Special thanks go to Susanne Whitmore for sending me a large box of photographs taken by her late father, veterinarian Dr. George Stringham, whose hobby had been to make copies from old photographic glass plates. Also, thanks go to George Storey for generously offering his collection of local postcards and to the Hon. Peter Idema for allowing me to use pictures from the town hall's collection. In addition, thanks go to Bernie Rudburgh, who assisted in scanning photographs and who allowed me to draw from his railroad collection. Also, special appreciation goes to Steve Suriano of Hopewell Photo & Graphic Center for his skill and patience in scanning and copying many of the photographs.

Many thanks go to the following for providing photographs and information that has been incorporated in this book: Varick Van Wyck Stringham, Arthur Church, Lynn Nestler, Don Nickerson, Dale Cunningham, Shirley Matthews, Richard Teed, Willa Skinner, Dick Valinski, Claude Angot, Marie Goodwin, Fishkill Historical Society, New York City Historical Society (John and Sally Jay portraits), Penny Brown, Elaine Hayes of Mount Gulian Historic Site, and Hopewell Fire Commissioners.